IMAGES
of America

AROUND
BRONXVILLE

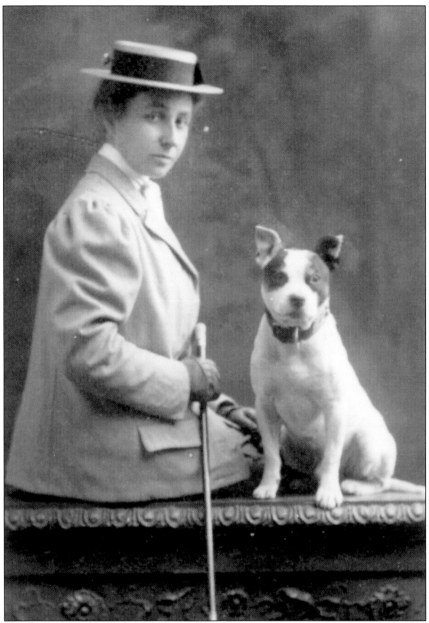

Amie Sykes Dusenberry (1870–1959), in her familiar suit and tie, is shown in 1906 with her dog, Beaux. Her lifetime spanned the two centuries illustrated in this book, and her life's work illuminated the variety of topics included in its purview. Descendant of a "founding family," this youngest child of Elias and Mary Masterton Dusenberry lived her entire life in the family homestead. Her vocation was "serving God and community" as welfare officer and overseer of the poor, church teacher, daily hospital visitor, fund-raiser, leader of women, patriot, and keeper of the last village cow! Almost every long-term resident has a story to tell about Miss Amie. For some, the anecdotes of her life have become legend; for others, the story of Miss Amie has become the story of Bronxville.

IMAGES
of America

AROUND
BRONXVILLE

Marilynn Wood Hill and Mary Means Huber

ARCADIA
PUBLISHING

Published by Arcadia Publishing
Charleston SC, Chicago IL, Portsmouth NH, San Francisco CA

Printed in the United States of America

Library of Congress Catalog Card Number: 2008935734

For all general information contact Arcadia Publishing at:
Telephone 843-853-2070
Fax 843-853-0044
E-mail sales@arcadiapublishing.com
For customer service and orders:
Toll-Free 1-888-313-2665

Visit us on the Internet at www.arcadiapublishing.com

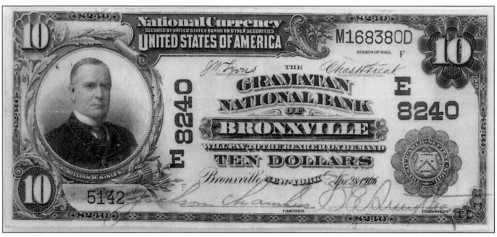

This United States currency was issued under the name of the Gramatan National Bank of Bronxville in 1906, the year the local bank was founded. Engraved on the ten dollar bill is a portrait of William McKinley, who was president of the United States in 1898 when Bronxville was incorporated. The connection between the village and McKinley's tenure in office is reinforced through area street names. On the Bronxville-Tuckahoe border is McKinley Street, and one block south is Hobart Street, a tribute to McKinley's vice president, Garret Augustus Hobart.

Contents

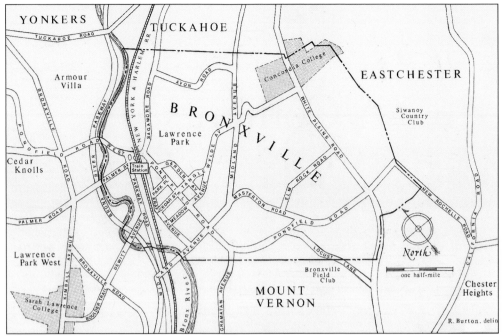

An area map of Bronxville and the surrounding communities before World War II.

Acknowledgments

Those photos that have not come from the Local History Collection of the Bronxville Public Library have been noted by a parenthetical notation at the end of the caption. The following sources have kindly provided photographs for this book: AAAL (American Academy of Arts and Letters), AU (Amy Unfried), BFC (Bronxville Field Club), BL (Bronxville-Ley Real Estate-BH+G), CC (Concordia College), CK (Christina Krupka), CSC (Christian Science Church), EB (Elliott Bates Jr.), EHS (Eastchester Historical Society), FB (Fielding Bowman), GN (Gannett Newspapers), HL (Houlihan-Lawrence Realty), JFK (John Fitzgerald Kennedy Library, Boston), JP (Jack Polak), LBH (Little Bighorn National Park, Montana), LH (Lawrence Hospital), LP (Lawrence Park Hilltop Association), MF (Mrs. Morgan's Flower Shop), PP (Paul Parker), RR (Robert Riggs), SCC (Siwanoy Country Club), SH (Seth Harrison), SJ (St. Joseph's Church), SLC (Sarah Lawrence College), SS (Steve Shepard), VG (Vicky Gomez), and WH (William Hilton).

We also appreciate the assistance or special contributions of Eastchester Photo Service, former Village Historian Jean Bartlett, Claudia Keenan, Madryn Priesing, Jayne Warman, and, of course, John and Charlie.

BRONXVILLE

100 YEARS

1898-1998

Introduction

At one time or another, every resident of Bronxville has had to explain to someone that Bronxville is not a part of the Bronx. Though both communities trace their names to the same seventeenth-century settler, Jonas Bronck, the histories of the two localities as well as the legends of their nomenclature have been very different. As far as we know, Jonas Bronck never stepped on the one-square-mile plot of southern Westchester County that is Bronxville, but the river that borders the village carries his name, and some say it was the inspiration for the renaming of the small hamlet in 1852. That was the year we got an official post office and postmaster, and with this elevated status, we adopted a new name.

One wonders what our first postmaster, Lancaster Underhill, thought when his neighbors decided to replace the community's original appellation of Underhill's Crossing with Bronxville. As long as anyone could remember, the place had been known by his forebears' name, an acknowledgment of the fact that several generations of his family had owned much of the land on which the community stood. Some years later, in 1915, perhaps the long-departed first postmaster looked down in amusement as opposing factions of the village argued over whether the name of their locality should once again be changed to either Gramatan or Gramatan Hills. Some even suggested Lawrenceville. But the Bronck legacy prevailed, Bronck was shortly thereafter memorialized in a village logo, and the community has been happy to be Bronxville ever since.

In structuring this visual history of Bronxville, we endeavored to hark back to the sense of community that originated in an earlier Underhill's Crossing, and one that still exists today. This community is a broadly encompassing group of southern Westchester neighbors whose lives are so intertwined that the boundaries of their different geographic areas become indistinct. Many Bronxville residents have previously lived in the Yonkers neighborhoods of Cedar Knolls, Lawrence Park West, or Armour Villa; in the Eastchester communities of Tuckahoe or Chester Heights; or in Mount Vernon. Many others will move into these neighborhoods later in life. Regardless of which of these places one calls home, most of us work, worship, study, volunteer, shop, socialize, and even get our 10708 mail together as one community. Our collection of photographs suggests that it has always been this way, and most residents assume that this communal spirit will prevail into the next century.

There are, of course, some distinctions. As Bronxville celebrates the centennial of its incorporation, we are aware of the particular benefits this small municipality has bestowed upon its tax-paying residents: a nationally recognized public school system that has nurtured

its children; a carefully planned suburban development that has enabled Bronxville to retain the small-town charm of an earlier era; and a civic-minded, interesting, generous, and, yes, prosperous citizenry that has savored the good life the village has offered. For some, however, the mirror image of such a community is one that seems insular and somewhat self-satisfied. But then, this is the kind of tension from which social history is made.

This photographic history of the Bronxville area is a social history; it is not meant to be a comprehensive history. Guided by the collection of photographs—the selective availability, condition, and clarity of images—we have tried to develop the story of a broader Bronxville by stressing particular themes. Our emphasis on vintage photography has meant that the book focuses primarily on the area's history from the nineteenth century through World War II. As a result, many worthy individuals, organizations, and events have not been included. That part of Bronxville's story will have to be told in future volumes.

The first two chapters of this book focus on Bronxville in the nineteenth century, from the coming of the railroad in 1844 through the turn of the century when the few hundred residents of this small rural village began to envision their locality as a unique suburb. Bronxville's founding families such as the Mastertons and Lawrences featured prominently in this creative process of community-building, melding together different styles, personalities, and philosophies for a common purpose. The year 1898, when Bronxville was incorporated, has taken on symbolic significance in local history; it represents both a threshold from the nineteenth to the twentieth century, the old to the new, and our transition from a rural hamlet of prosperous farmers to a young municipality that would become one of New York City's most desirable suburbs. The biggest change in the face of the village came in the 1920s and 1930s when the commercial district filled most of the geographic area it does today and the last of the village's small industries closed its doors. By then, the flourishing railroad and the popular automobile had affirmed Bronxville's role as a commuter's haven.

Several aspects of Bronxville's public and private lives have been fundamental to its development. Firmly rooted in the last century, religion and education have remained cornerstones of the community structure. Bronxville's position as a fashionable suburb also has influenced its history. The gracious way of life and elegant homes that charmed its long-ago inhabitants continue to attract business leaders as well as artists, and even some celebrities. Another perspective on Bronxville's history is gained by observing how residents have spent their leisure time—from the countless hours volunteered in service groups to an enthusiasm for sports and recreation that has made organizations and clubs a major part of the local lifestyle. Our final view of the community focuses on how we have celebrated ourselves. From our earliest years, pageants and parades have been an integral part of our village experience. For over a century we have gathered annually both to celebrate and commemorate, reenacting traditions and confirming values that have been part of our collective past.

The majority of the photographs in the book are from the Local History Collection in the Bronxville Public Library. Over the years, residents have contributed a large number of images, including many vintage photographs that have been very important in the documentation of our early history. The village was fortunate to have had several photographers of note who lived and worked here in the area's formative years. Most of the earliest photos of the village were taken by resident-photographer Frederick Sprenger, who seems to have gone from rooftop to rooftop creating "bird's-eye views" and braved all kinds of weather, even the Blizzard of 1888, in order to capture a glimpse of life in his late-nineteenth-century community. Sprenger was followed by others in the 1920s and 1930s, including John Gass, James Owen, and Carroll Guest.

To these professional photographers, as well as others in the area who have loaned us photos from family albums, we are grateful. Some of the early cameramen recorded for posterity parts of our community such as the Hotel Gramatan that have physically disappeared and will never be replaced. And others, in the split-second the shutter opened, artfully captured the mood and spirit of a nostalgic but bygone era.

One

Nineteenth-Century Bronxville:

The Early Village and Its First Families

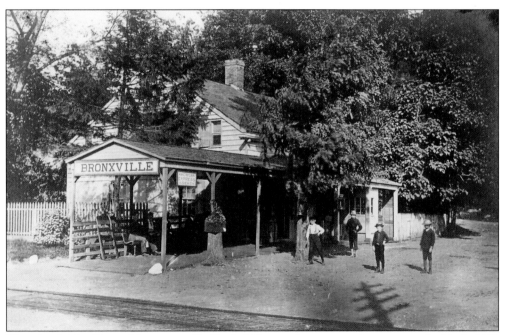

The simple dwelling of Lancaster O. Underhill was the center of commerce in Underhill's Crossing, the rural community that would become the village of Bronxville. The New York Central Railroad came through the area in 1844, but regular stops and mail delivery did not begin until 1852 when the town was officially renamed Bronxville. Underhill's home, located on the east side of the tracks, became the first railroad station and post office, and it remained standing until about 1898.

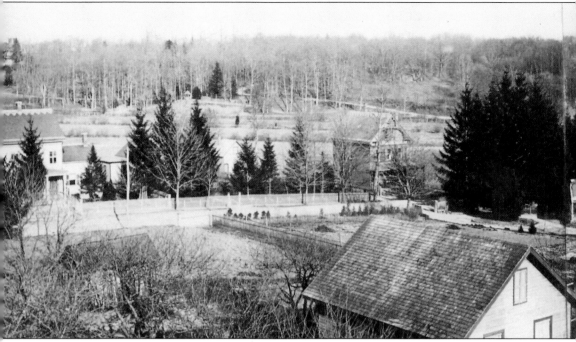

In two panoramic photos taken from Cedar Street in the 1880s, photographer Frederick Sprenger offers a bird's-eye view of Bronxville. TOP: The view to the east along Pondfield Road shows the fields on Midland Avenue destined to become the site of the Bronxville School. To

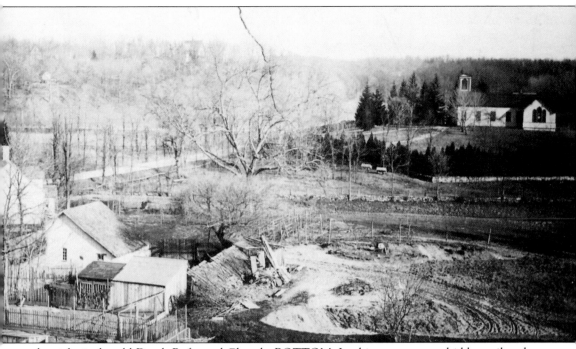

the right is the old Dutch Reformed Church. BOTTOM: Looking west across hidden railroad tracks and the Bronx River, the buildings of Yonkers and Armour Villa mark the skyline. Note the tiny Underhill depot to the right, and to the far right, the back of the 1870 school.

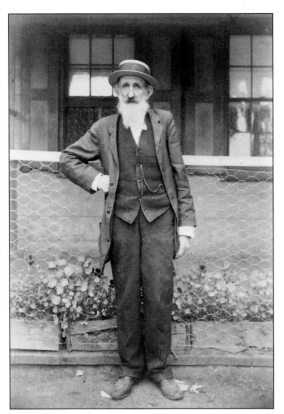

Stationmaster Lancaster O. Underhill, descendant of Bronxville's first farm family, was the village's first postmaster, appointed in 1852 by President Millard Fillmore. After forty-four years of service, he was replaced by a local businesswoman. He was remembered in his early days as a "spiffy dresser." His death in 1898, the year the village was incorporated, symbolized the passing of the Victorian era and the advent of modern Bronxville.

Approaching the old station from the east, by way of Kraft Avenue, *c.* 1890, Pondfield Road crosses the unguarded grade-level tracks as Swain Street (later Pondfield Road West) continues toward Yonkers. The sign advertises Armour Villa Park across the Bronx River. The white gabled house ahead was soon replaced by the stone and half-timbered Stoneleigh.

The Abijah Morgan house, the earliest surviving village dwelling, stands on the northeast corner of White Plains and Pondfield Roads. The exact date of the building is unknown, although the Morgans owned the land in the eighteenth century. In the War of 1812, regiments from the area assembled at Ensign Morgan's home to march to Ft. Hamilton to defend New York Harbor, which had been blockaded by the British.

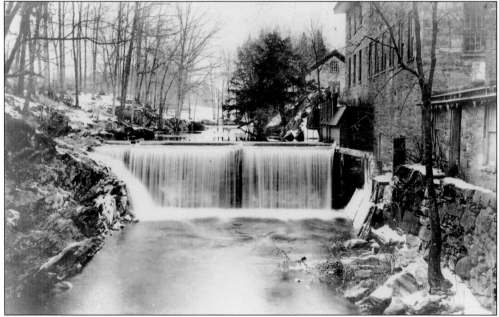

When James P. Swain came to the area in 1840, he bought land on both sides of the Bronx River where the Underhill family had run a grist and sawmill. Swain and his partner, father-in-law James M. Prescott, built a three-story stone cutlery factory on the site and the firm prospered until after the Civil War. Eventually, the Ward Leonard Electric Company bought the building. River House co-op apartments stand here today.

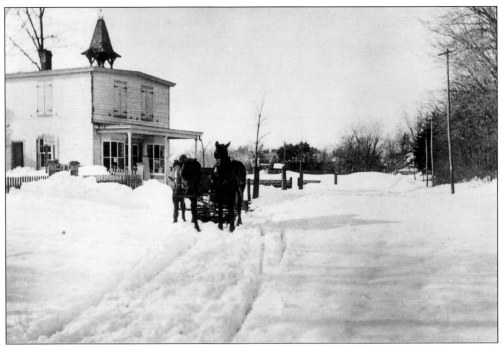

The Tyler sisters' grocery and candy store on the southwest side of Pondfield Road near Park Place was photographed after the Blizzard of 1888. The cupola of the 1870 public school next door appears to be part of the store roof. The Swain house and the railroad station are barely visible in the distance.

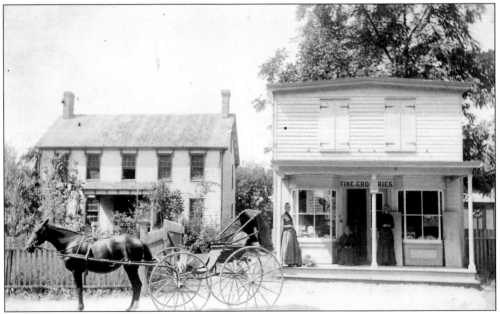

The "Fine Grocery" run by Ann Matilda Tyler Smith and her sister, Tilly Ann, was located between their 1849 homestead and the school. Mrs. Smith became the postmistress in 1896, replacing Underhill. Continuing his tradition, she read all incoming postcards. In 1906 the post office was moved into the newly erected village hall.

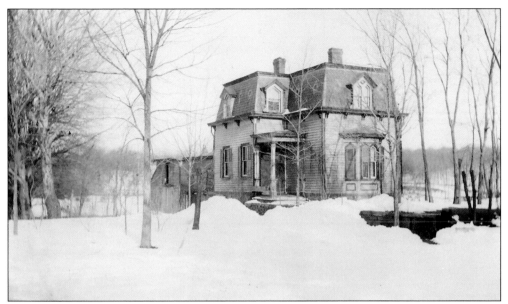

Alfred E. Smith's stylish Second Empire-design home at the corner of Pondfield Road and Tanglewylde was photographed after the Blizzard of 1888. Midland Avenue appears in the far background. Smith was nicknamed "Axle" because he made carriage axles at his Swain Street business across from the cutlery factory. A gas station was later built on the site of the house, c. 1930.

An 1890s advertisement for John Kane's blacksmith shop, located on the site of the old village hall, read "Horse shoeing and repairing of every description. Particular attention given to road and interfering horses. Carriage, coach, and wagon painting done in the best manner."

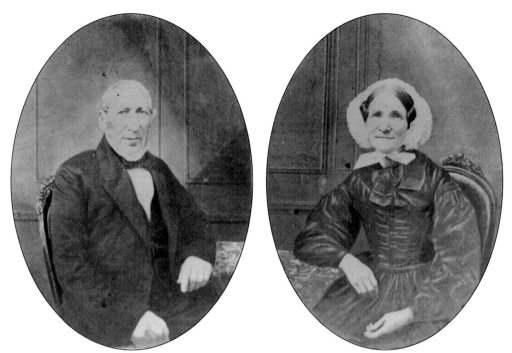

Alexander Masterton Sr., a stone mason, immigrated to New York from Forfar, Scotland, in 1815. In the 1830s he purchased marble quarries near Tuckahoe and built a home in Bronxville. His flourishing business established the Mastertons as one of Bronxville's leading families. Masterton and his New York-born wife, Euphenus Morison Masterton, had seven sons and a daughter who survived infancy.

In 1835, the Mastertons built this home on White Plains Road. The porch incorporated some of the best classical wooden ornamentation found in Westchester County. In the earliest known photograph of the building, *c.* 1860, gentlemen are admiring a circular garden bordered with boxwood hedges. The original 11 acre estate was later increased to over 100 acres. (RR)

Alexander Masterton Jr. was a successful banker in New York and a charter member of the Bronxville Dutch Reformed Church. He was a beloved superintendent of the Sunday school, but his life was not without tragedy. His home on Hemlock Road had to be completely rebuilt as a result of a theft and arson in 1879, and in 1899 he was murdered by a deranged client. Part of his 11 acre estate and his fine home at 15 Hemlock Road later became a private boys school, the Massee Country School.

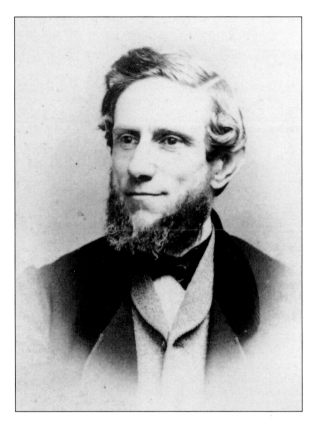

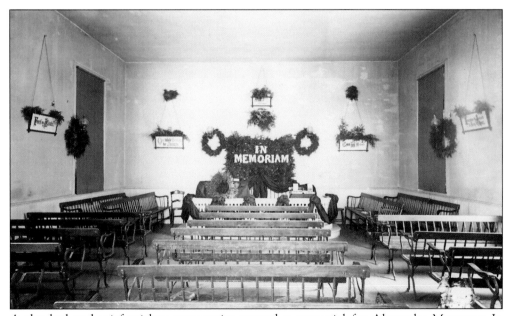

A shocked and grief-stricken community created a memorial for Alexander Masterton Jr. after his murder in 1899. The Reformed Church Sunday schoolroom, which was donated by Masterton in 1873 in memory of his sons, was draped in mourning crepe and boughs.

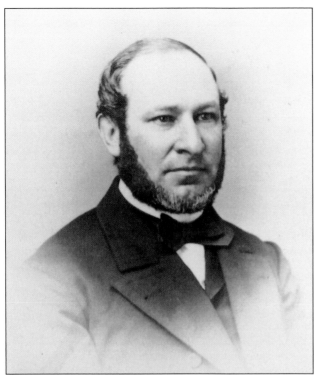

Robert, the oldest Masterton son, was a tea merchant in New York City. Locally active in education and politics, he served as second president of the District #2 Board of Education, and he was an Eastchester Republican leader and a delegate to the party's national and state conventions. He died of a heart attack in the great Blizzard of 1888 trying to reach home.

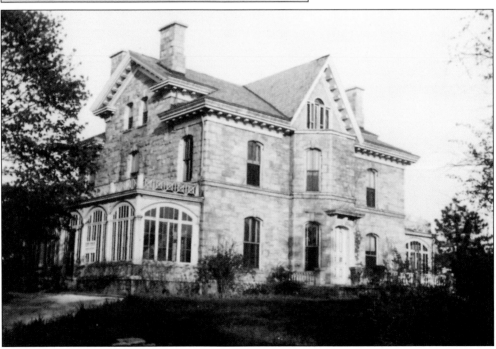

Alexander Masterton Sr. gave each of his sons land on which to build homes. Robert's 11 acres included the old Abijah Morgan house where he lived until he built his stone mansion nearby. At the turn of the century the home became Dr. Granger's sanitarium. This house stood in the vicinity of Manor Road until it was razed in 1957.

In 1889, members of Robert Masterton's family posed on the piazza of his elegant home. The taller boy (far left), grandson Bertrand Burtnett, later became a state legislator.

These photos of the Masterton grandchildren were taken from the family album. The boy, Elias, born in 1861, is shown here wearing a Civil War-era sailor suit. A businessman, he was the first treasurer of the Village of Bronxville, a school district officer, and an avid gardener. The portrait of the unidentified granddaughter is reminiscent of a Lewis Carroll photo.

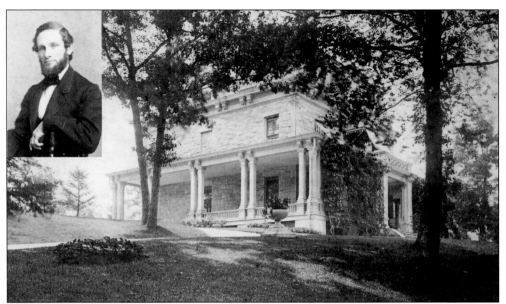

Oakledge was John Masterton's handsome stone residence which still stands near the intersection of Pondfield and Oakledge Roads. Architect Lewis Bowman completely remodeled the building in the 1920s. John, the youngest Masterton son (overlay), carried on the quarry business after his father's death in 1859. He was the first Republican Supervisor of Eastchester and a founder of the Eastchester Savings Bank. (RR)

An 1886 view of Masterton Road ascending from Midland Avenue through Masterton Woods shows cousins Bertrand Burtnett and Marie and Alexander Ferris heading for school or church on a road built by and named for their grandfather, Alexander Masterton Sr.

When James Minot Prescott joined his son-in-law, James P. Swain, in the cutlery business in the 1840s, he purchased 86 acres of hilly farmland that would later become Lawrence Park. In about 1850, he built this large Italianate stone Manor House that is still standing on the road that now bears his name.

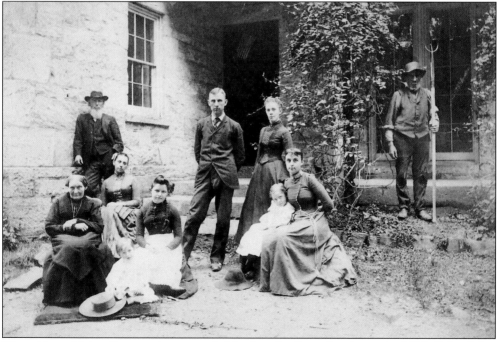

The widowed Mrs. Prescott is surrounded by her family at her home in 1889. Behind her is Lt. Col. Alfred E. Latimer, who served in the Union Cavalry in the Civil War and later was an "Indian fighter" in the Northwest. He was a roommate of General Phil Sheridan at West Point. On the far right is Latimer's servant, John Slevin, who served as "batman" to Latimer in the military.

Mary Araminta Swain Smith (right), granddaughter of Mrs. Prescott, married Dr. David E. Smith, Bronxville's first doctor. Her Bronxville diary, which spans 1858 to 1899, is a rich source of local history. She catalogued the day-to-day activities of a Bronxville housewife and told the sad tale of the economic decline of her grandmother Prescott, a story similar to that of many elderly widows of the time. Here Mrs. Smith appears with two unidentified friends, c. 1890.

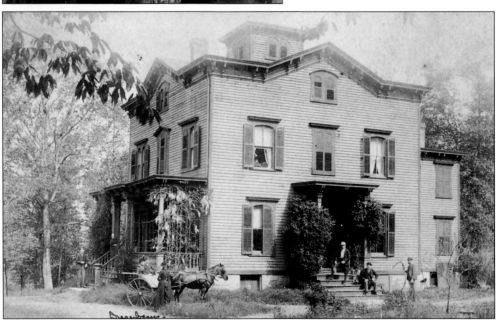

David and Mary Araminta Smith built their home, Cozy Nook, on Dusenberry Avenue (now Sagamore Road) at Beechtree Lane. Members of the Dusenberry family have arrived in their buggy for a visit while the Smiths wait on the porch of the house, c. 1890.

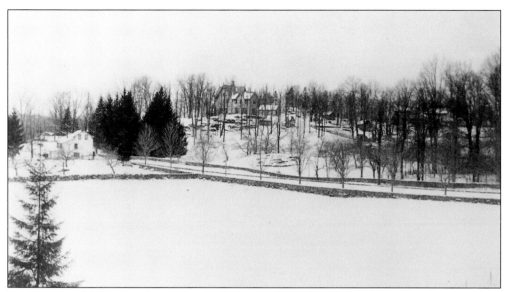

The first Crow's Nest mansion and outbuildings perch on the wooded hill overlooking Pondfield Road. The Gothic Revival home was completed in 1850 for banker Francis W. Edmonds, an artist and member of the National Academy. His 30-acre estate was bordered by Midland Avenue and Masterton Road on the north and the Bronx River on the south.

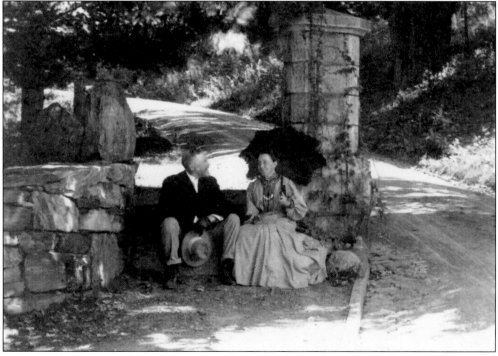

Frank R. Chambers and his wife, Kate, rented the Crow's Nest house in 1888 and later purchased the estate. Mrs. Chambers described her first impression of the place as "a quaint, gabled stone house with far sweet views from the porch." Chambers, who was born and raised in Alabama, quit school at age eleven to work in a Confederate arsenal. He became president of Rogers Peet & Co., a men's haberdashery, and was a leading Bronxville citizen.

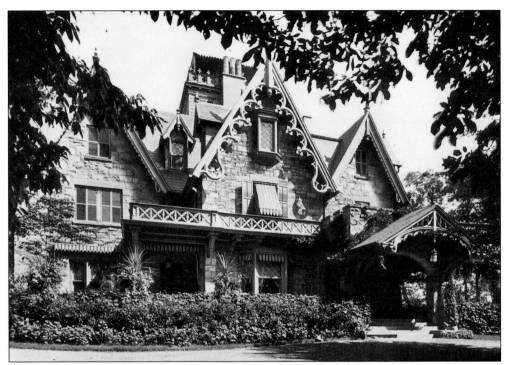

Crow's Nest was extensively renovated in 1896–97. The Chambers' architect added gables, a new porch, a kitchen, and interior details such as a Tiffany window and elaborate paneling. Other additions included a large carriage house-barn, coachman's house, and gardener's cottage.

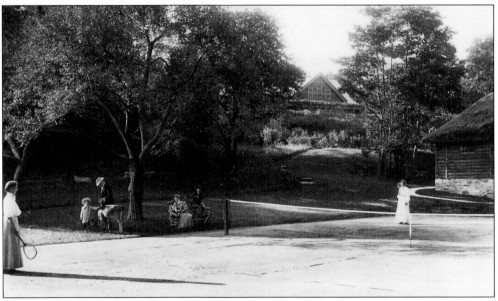

The Crow's Nest grounds included a tennis court, marble swimming pool, numerous garden buildings, and an arbor. The Chambers were greatly admired for their philanthropy, hospitality, and devotion to volunteer service at the school and the Reformed Church. The village hall, the public library, Alden Place, and many homes now stand on what was once the Chambers' land.

Two

The Lawrence Legacy:
A Vision of a Model Community

William Van Duzer Lawrence must have walked past this nineteenth-century gate house when he first visited Bronxville and the Prescott Farm in 1888. Though he thought the farm's 86 rocky and hilly acres "worthless for either agriculture or town development," he began to envision the area divided into "pretty little villa sites for artists . . . or some similar class of people." Lawrence Park, one of Westchester County's first planned communities, was the result.

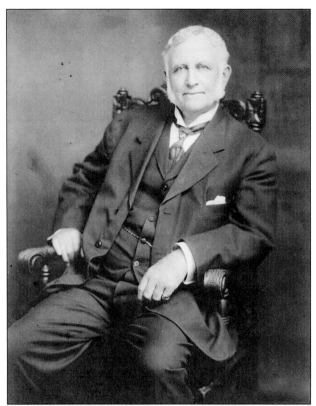

Much of Bronxville's unique character is the result of the creative vision and planning of William Van Duzer Lawrence (1842–1927). A native of New York, Lawrence moved to New York City in the late 1880s after building a successful pharmaceutical company in Canada. He was not only the founder and developer of Bronxville's Lawrence Park and Yonkers' Lawrence Park West, but was also the driving force for the establishment of Lawrence Hospital and the founder of Sarah Lawrence College.

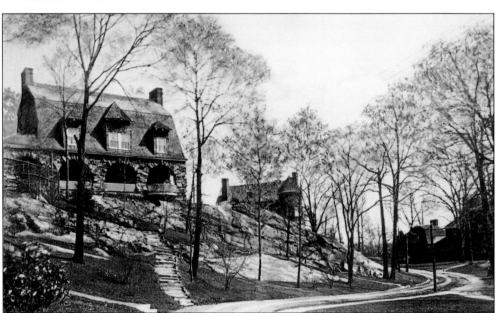

Grey Arches, a stone and shingle house at 12 Sunset Avenue, was one of the first Lawrence Park houses to be built in Lawrence Park in the 1890s. Perched on a steep rock ledge, with commanding panoramic views, Grey Arches became the Lawrence family's summer home after its completion in 1891. The home of artist Will Hicock Low is next door.

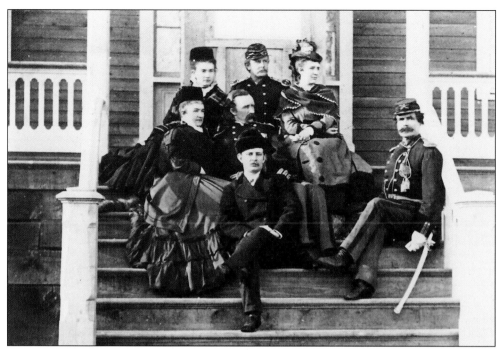

Several of Lawrence Park's earliest residents were family and friends of William Lawrence. Mrs. Lawrence's sister, Agnes Bates Wellington, and the Bates sisters' childhood friend from Michigan, Elizabeth Custer, were early homeowners in the park. Both women are pictured here (far left) in 1874 with General Custer (hatless) during the year Agnes Bates lived with the Custers at Fort Lincoln, Dakota Territory. (LBH)

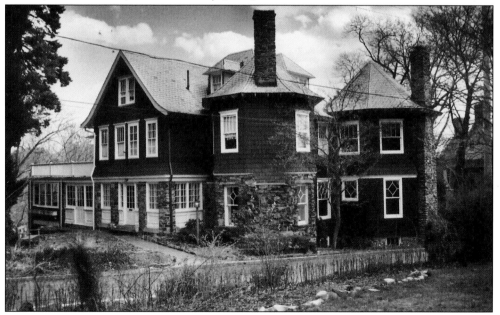

After she was widowed in 1876, Elizabeth Custer moved to New York City and became a writer. In the 1890s she built her first Bronxville home at 20 Park Avenue, next door to the home of her good friend Agnes Bates Wellington. (LP)

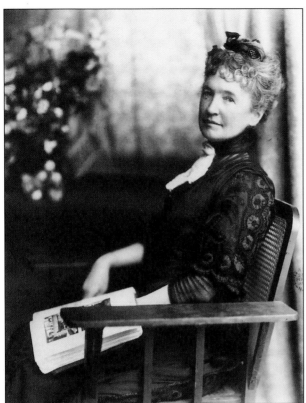

Elizabeth Custer as she appeared in her late fifties (c. 1900), when she was often in residence in Bronxville in either one of her two homes or at the Hotel Gramatan. Her books and lectures on her experiences in the West were very popular. Mrs. Custer, who never remarried or had children, considered the Bates and Lawrences her family, traveling and spending holidays with them. She named her second Lawrence Park residence "Laurentia" in honor of Sarah and William Lawrence. (LBH)

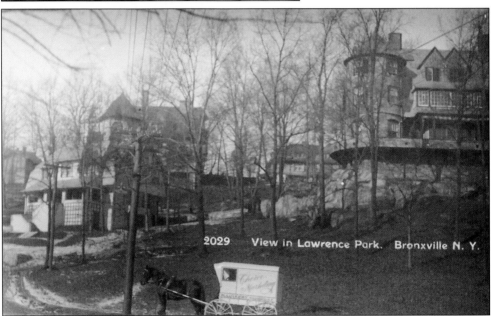

The hills of Lawrence Park presented a challenge to the horse-drawn delivery wagon from Choice Marketing in Tuckahoe. To the left is the home of Col. Charles Bates, retired military, who wrote articles about General Custer; and to the right is Elizabeth Custer's second Lawrence Park house at 6 Chestnut, built c. 1902.

Edmund Clarence Stedman, well-known in the late nineteenth century as the "Poet of Wall Street," was one of several writers who resided in Lawrence Park around the turn of the century. He worked at the New York Stock Exchange during the day and wrote poetry at night. Though his poetry is not widely read today, at the height of his career the New York literary world considered him the foremost man of American letters. (AAAL)

Clarence Stedman's Colonial Revival mansion, Casa Laura, on Wellington Circle is one of Bronxville's most attractive residences. While living here, he compiled an anthology of American poetry, his most well-known work today.

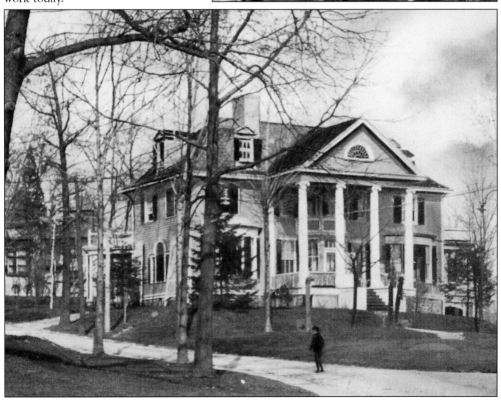

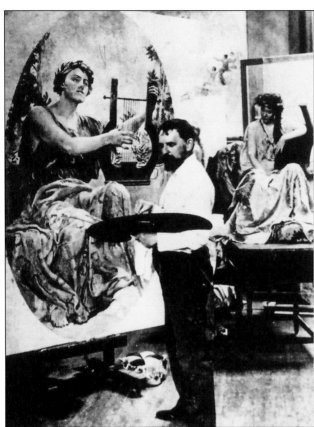

Will Hicock Low is shown painting in his studio at his home at 25 Prescott Avenue. His studio was a customized addition made by William Lawrence when Low decided to move to the park in 1897. Low is known for his murals, such as those commissioned for the old Waldorf Astoria ballroom. His wife, Mary Fairchild MacMonnies Low, was an American Impressionist painter.

Herman Schladermundt (left), shown with two friends in his carriage, was another artist who was drawn to the charming artistic community that thrived in Lawrence Park. Schladermundt is best known for his architectural decoration, such as the mosaic vaults in the Congressional Library in Washington, D.C., and a frieze that decorated the Hotel Gramatan.

The Meigs house at 42 Prescott was completed in 1898 for newlyweds Louise Lawrence Meigs, oldest daughter of Sarah and William Lawrence, and her husband, Ferris Jacob Meigs. All of the house except the stone music room on the right was destroyed in a 1950 fire. This wing has been incorporated into two houses subsequently built on the location.

Louise Meigs, an 1891 graduate of Vassar and mother of three daughters, is shown reading on the piazza of her Prescott home. Living in the home with the family of five were four employees: a governess, nurse, cook, and waitress.

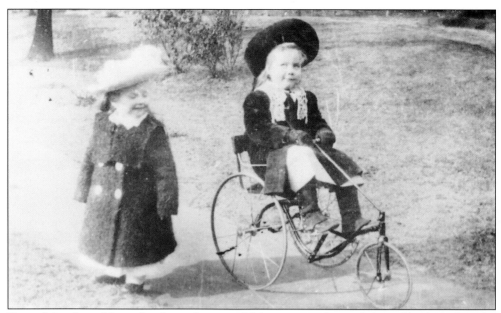

Two of the three Meigs daughters, Lucia and Margery, are shown fashionably dressed in the early 1900s as they play near their Bronxville home. Hester, the youngest sister, is not shown.

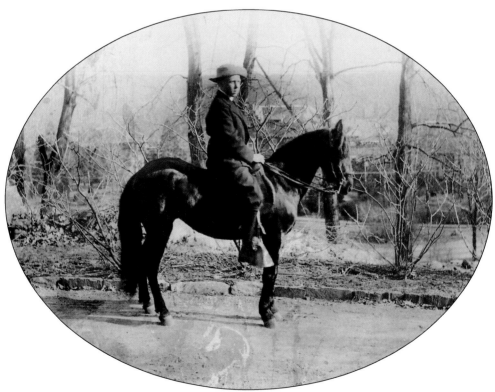

Elliott Bates, cousin of the Meigs girls, is shown about age twelve riding his pony on Prescott Avenue. After serving in World War I, he returned to make his home in Bronxville. (EB)

Adele Bates, older sister of Elliott, is wearing her 1907 wedding dress. She married Richard Charlton, Bronxville's first obstetrician and gynecologist. Adele and Elliott were children of John Bates, brother of Sarah Lawrence, and grew up at 29 Prescott Avenue. The Charltons also raised their family in the Prescott Avenue home, and both were active in community organizations and Christ Church. (EB)

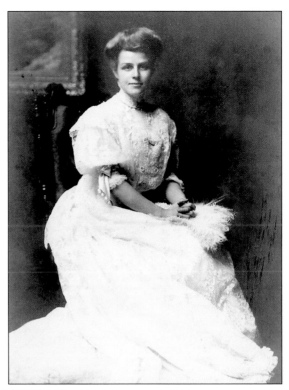

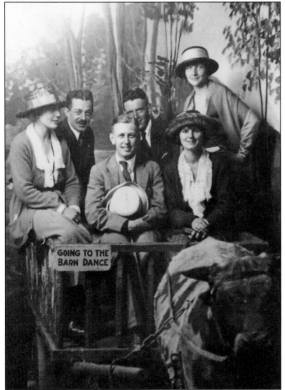

GOING TO THE BARN DANCE

As young adults, the Bates and Meigs cousins enjoyed the gay social life of Bronxville and Westchester County in the roaring twenties. Elliott Bates (center) sits next to cousin Lucia Meigs and her husband, architect Penrose Stout (left), and Margery Clifford and other friends (right). Penrose Stout was employed by the Lawrence enterprises and designed a number of Bronxville homes and buildings. (EB)

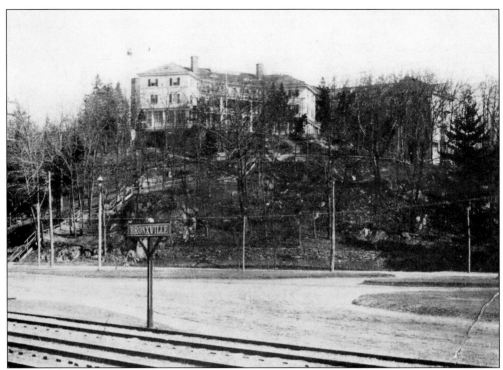

The Gramatan Inn, on Sunset Hill overlooking the train station, was built in 1897 by William Lawrence to accommodate guests coming to Bronxville to enjoy "the country" and the social and cultural life of Lawrence Park. This building was destroyed by fire three years after it was built, in April 1900.

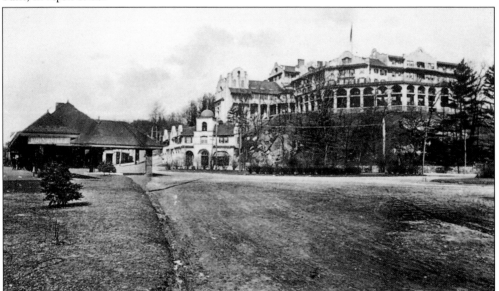

The Hotel Gramatan, completed in 1905 to replace the Gramatan Inn, was a much grander hotel than its predecessor. Its luxurious furnishings drew guests from all over the country. The hotel had 300 guest rooms with 165 private baths, three restaurants, a spacious lobby, and a large ballroom.

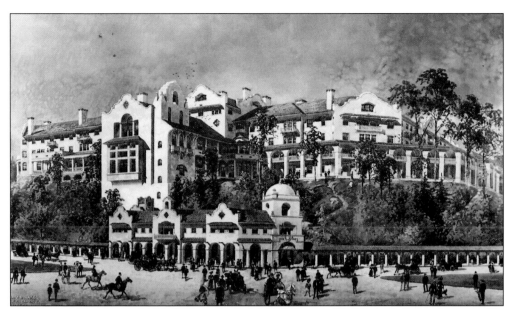

The striking view of the Hotel Gramatan towering over Bronxville and its environs was an inspiration to a number of artists and photographers. This painting by Hughson Hawley was commissioned for the hotel's opening in 1905. Another painting of the hotel by Mrs. Jefferson Davis hangs in the Davis home in Biloxi, Mississippi. Mrs. Davis was only one of many celebrities who stayed at the Gramatan over the years. Others included Theodore Roosevelt, the Barrymores, Greta Garbo, Gloria Swanson, Theodore Dreiser, and Eleanor Roosevelt.

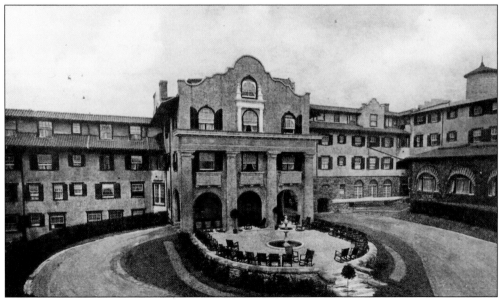

The courtyard and porte-cochere side of the Hotel Gramatan provided an elegant setting for arriving guests as well as those relaxing in rocking chairs around the fountain. The hotel's Spanish Mission-style architecture with tile roof, a contrast to Lawrence's other buildings, was fashionable at the turn of the century.

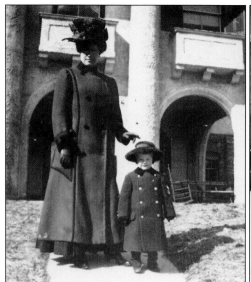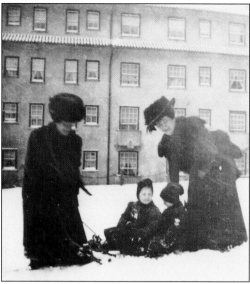

Mrs. Gray and child, guests from California, are shown in 1908 enjoying the lawn of the Gramatan before and after a winter snow. The Gray family later became residents of Bronxville, moving into a large home at 2 Governors Road. Their daughter, Jane, would become the bride of Elliott Bates in the 1920s. A few months after the Gray's 1908 visit to the Gramatan, the hotel caught fire and seventy rooms in the east wing were destroyed. The reconstructed wing opened six months later on Christmas day. (EB)

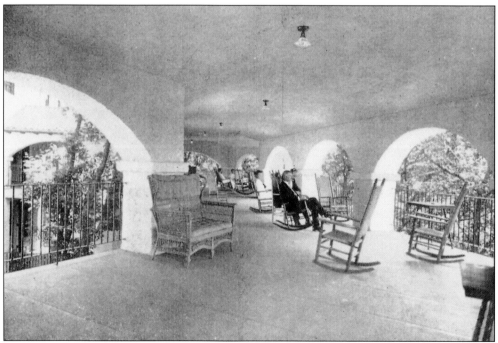

The peaceful piazzas of the Gramatan offered views of the New York skyline as well as glimpses of Lawrence Park's attractive homes. The hotel brochure claimed that from its wide verandas one could see "from the Palisades to the Long Island Sound."

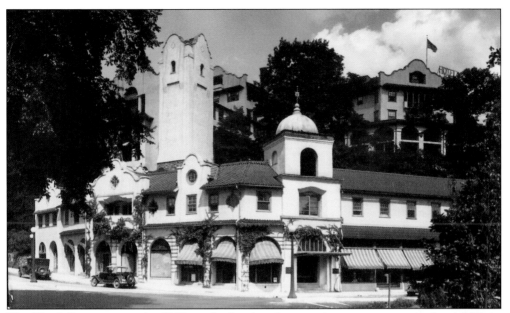

The Hotel Gramatan, in the 1920s at the height of its popularity, was a center of social life in southern Westchester County. Weekend dance bands were a major attraction.

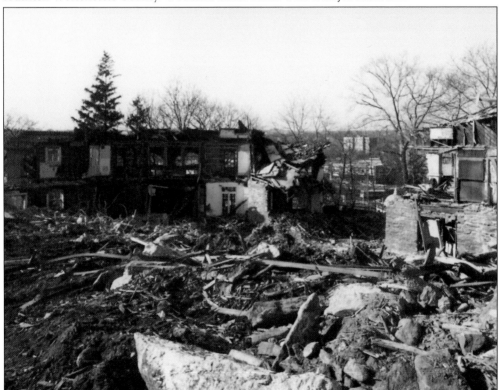

The demolition of the Gramatan in 1972 was a sad event for many who remembered the hotel in its grander days. Some historic preservationists tried to save the Bronxville landmark but were unable to demonstrate that it could again become economically viable. (WH)

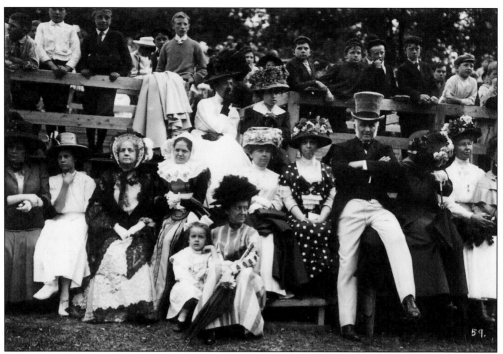

Another of William Lawrence's legacies is Lawrence Hospital. Sarah Lawrence, third from left, and William, in top hat, are shown at the 1909 Westchester Pageant held in Bronxville to raise money for Lawrence Hospital.

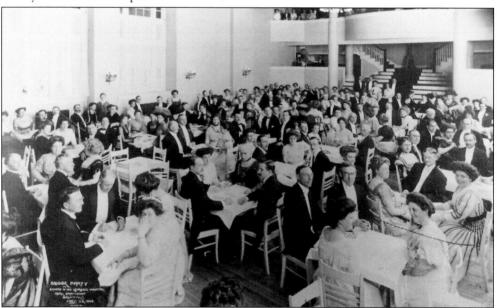

A second 1909 fund-raiser for Lawrence Hospital was this formal bridge party held in the ballroom of the Hotel Gramatan the night before the pageant began. Though the funds donated by Lawrence for the hospital were far greater than those raised by various benefits, the involvement of so many villagers in supporting the hospital gave the community a sense of "personal ownership" that has been a hallmark of its continuing success.

The hospital, located on Bronxville's west side, was completed in 1909. Considered one of Westchester County's finest hospitals, it had thirty beds, with sixteen private rooms.

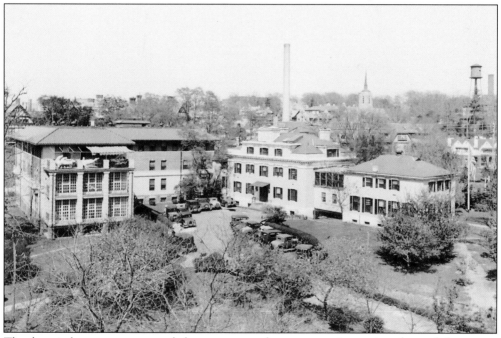

The hospital was soon expanded to accommodate an ever-increasing demand for space. Recuperating patients enjoyed sunning on the balcony of a new wing built on the northwest side of the original building in the 1920s. Christ Church's steeple is visible in the background.

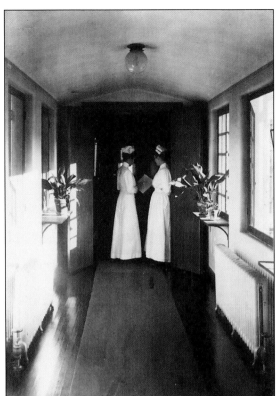

Two Lawrence Hospital nurses confer at the end of an attractive sunlit hallway, c. 1910. During its first year the hospital treated 278 patients. It was considered a pace-setter in its policy of admitting patients regardless of race or creed. Today, Lawrence treats a yearly average of 10,000 in-patients and 24,000 emergency cases. None of the original hospital exists and the facility now covers the entire block between Palmer Avenue and Pondfield Road West. (HL)

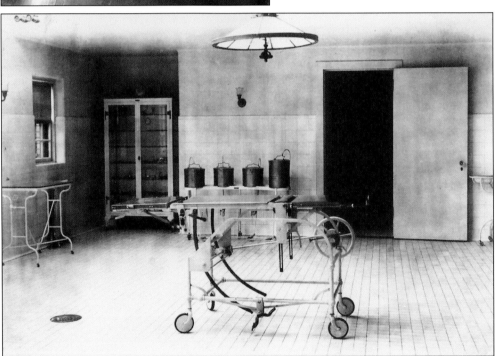

The hospital's first operating room, though desolate by current standards, featured the latest in medical design and function when it was constructed in 1909. (HL)

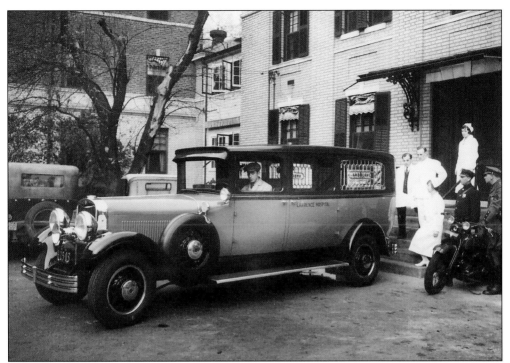

Lawrence Hospital purchased its first ambulance in 1917; following this, emergency vehicles were replaced every few years to keep up-to-date. The c. 1930 ambulance above is parked at the emergency entrance in back of the original hospital building. (LH)

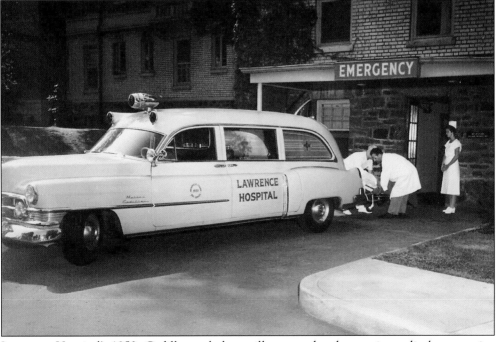

Lawrence Hospital's 1950s Cadillac ambulance illustrates the changes in medical automotive fashion over the years. The ambulance above was a gift from the League for Service. (LH)

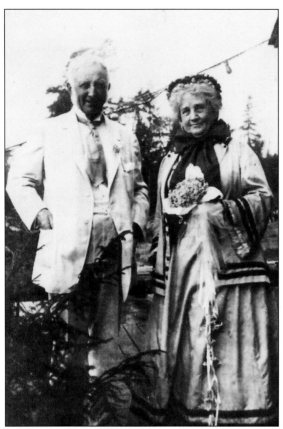

Sarah and William Lawrence, celebrating their 50th wedding anniversary in 1917, are wearing their 1867 wedding clothes. As with most women, Mrs. Lawrence's dress size had changed over five decades, so she had to tie the gown together across the back. In their later years, the Lawrences sold their Fifth Avenue home in New York City and moved to Lawrence Park West, a community of elegant homes Lawrence developed across the village line in Yonkers. (SLC)

One of the beautiful residences of Lawrence Park West was Westlands, the home Lawrence built for himself in 1917. This building and the 12 acres of land surrounding it became Lawrence's final legacy to the greater Bronxville community. When his wife predeceased him in 1926, Lawrence established Sarah Lawrence College in her memory and Westlands became the college's administration building.

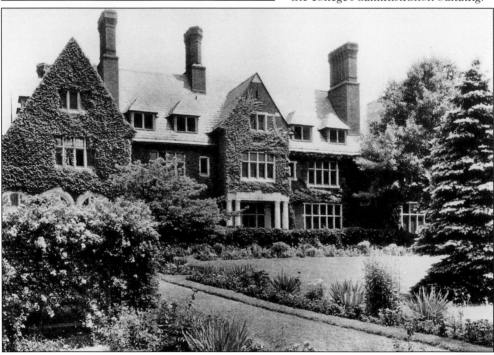

Three

After 1898:
Village Incorporation and
Community Expansion

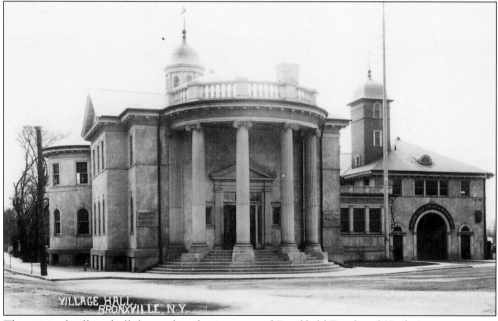

The original village hall, located at the juncture of Pondfield Road and Kraft Avenue, was an imposing classical structure that immediately captured the attention of passengers alighting from the northbound trains. In 1906, William Lawrence and Frank Chambers joined together to finance this first municipal center. The building housed not only village offices, but also a library, post office, fire house, gymnasium, swimming pool, bowling alley, and rooms for community meetings.

Bronxville's first president, Francis Bacon, was elected at a meeting of trustees held at his home in May 1898. A month earlier, on April 19, 1898, a local referendum had been held to determine if Bronxville should incorporate as a separate village within the Town of Eastchester. With a vote of twenty-five in favor and eight against, Bronxville began its transformation from a rural hamlet to a modern suburb.

The "first family" of Bronxville included Anna Hawes Bacon, shown here with daughters Rosalie and Anna. Both daughters became lifetime village residents who were active volunteers in the community. The son, William Bacon, served as the sixth president of the village from 1910 to 1911.

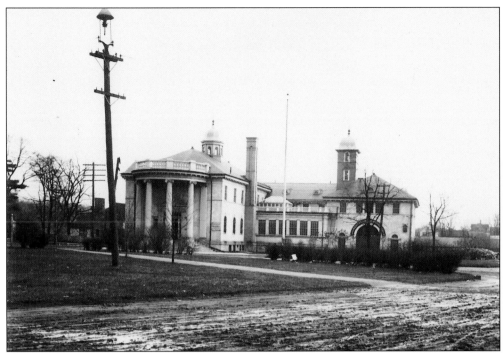

Though Bronxville's new town hall reflected the village's expansion and rising prominence, the community retained some of its rural character, as this scene with muddy streets illustrates. The entry to the fire department and the windows of the swimming pool are visible on the right side.

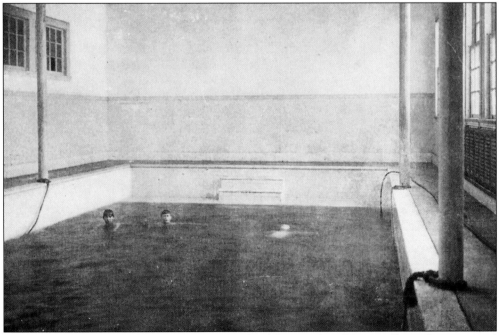

Students like these from the private Massee School (c. 1910) and Bronxville residents enjoyed indoor swimming at Village Hall. The pool was one of several municipal recreation facilities that were included in membership in the Bronxville Athletic Association.

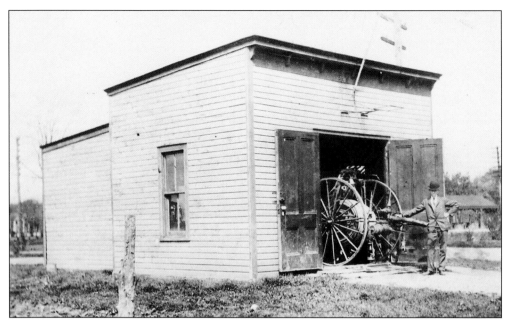

The Bronxville Hose Company, the village's first fire department, was organized in 1895 before the village was incorporated. The firehouse was located next to the railroad on the east side.

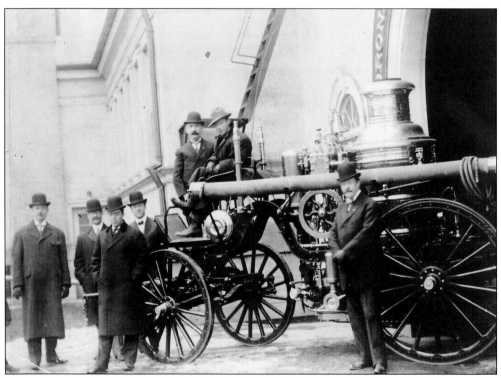

In 1906 Bronxville's modest firehouse and pumper were replaced by a wing of Village Hall and the latest in horse-drawn fire-fighting equipment. These dapper volunteer firemen, who would become the subject of a Jerome Kern musical, posed in front of the new fire engine, c. 1911.

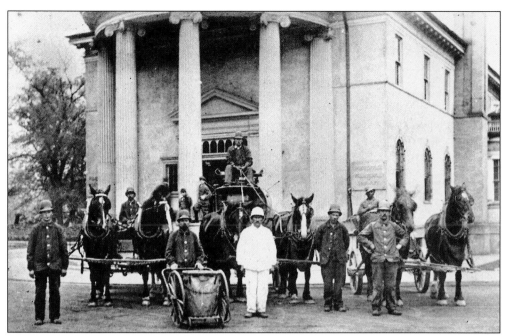

Once incorporated, Bronxville organized several municipal departments. In the days of horses and buggies, c. 1910, street cleaners played an especially important role in keeping village streets clean.

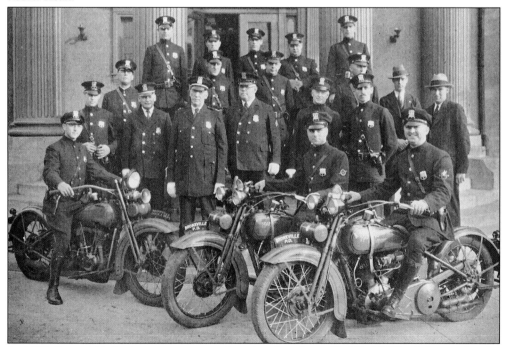

In 1898 Bronxville had a two-man, unsalaried police force. By World War I, law and order necessitated an expanded force. These members of the police force in the 1930s proudly pose in front of the new motorcycles which enabled them to keep the entire community under surveillance.

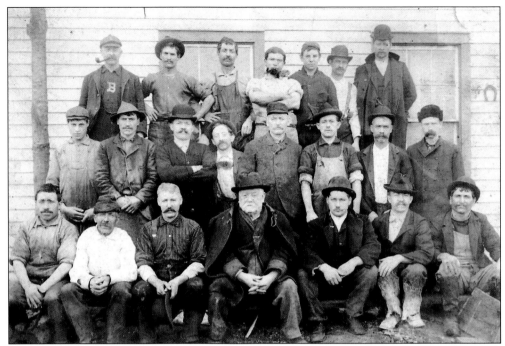

Frederick Kraft is seated in front of employees of the Kraft Tannery in 1902. The family came to Bronxville in 1880 and built a leather and glue factory along the railroad where Midland Gardens is today. In 1922 a fire destroyed the factory, closing Bronxville's last manufacturing enterprise. Most residents were pleased to be rid of the offensive processing odors.

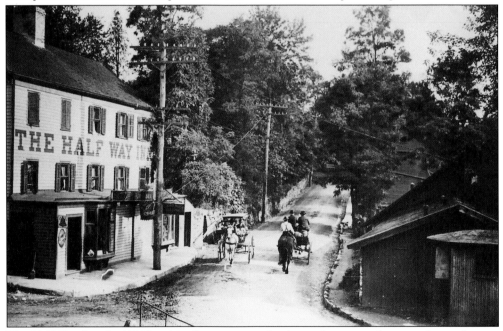

The Half Way Inn (*c.* 1890), originally constructed to house factory workers, was located across Swain Street (Pondfield Road West) from Smith's axle factory on a bend known as "Dead Man's Curve." Today, looking southeast up the hill, one can see Lawrence Hospital.

Before prohibition, Fred McGrath ran a popular saloon, the Olphert House, on Pondfield Road West. After Saturday night's last patrons had gone home, McGrath would go to St. Joseph's Church to set and light the furnace so the building would be warm for Sunday's Mass.

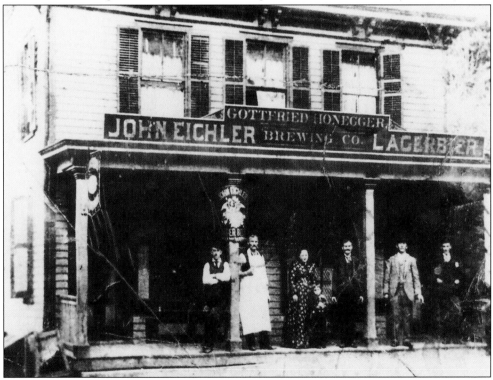

Just over the Bronxville line in Tuckahoe, Gottfried Honegger and his family owned the tavern shown here, c. 1900. The business, in operation since 1861, was purchased in 1968 by its current owners, the Salerno family, who have owned a meat market next door since 1930. (EHS)

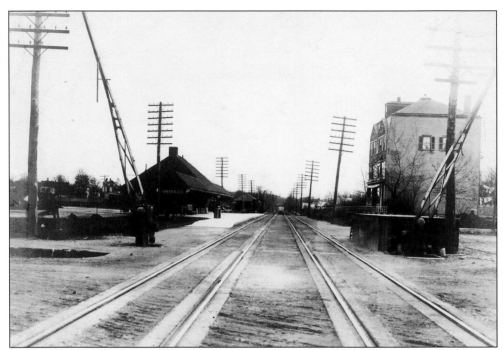

The Harlem Line of the New York Central Railroad became the main artery to and from New York until parkways were built. The second railroad station stood on the east side of the tracks from 1893 until 1915, across from Pick's store. Before the first Christ Church was built on Sagamore Road, the worshippers met at Pick's on Sunday mornings.

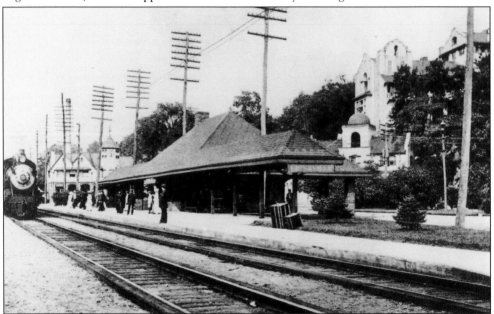

When the train to New York stopped to pick up passengers, it prevented traffic from crossing the street-level track. The eastern section of the Arcade Block on the site of Underhill's first railroad station, as well as the towers of the Hotel Gramatan, are a backdrop for the depot in this postcard view, *c.* 1910. (EHS)

Bronxville's easy commute to the city was a major reason for the development of the village as a suburban community. In a scene repeated for over a century, disembarking passengers are met by cabs, such as this horse-drawn surrey, c. 1900, or motorized versions in later decades. Palmer Road is in the background.

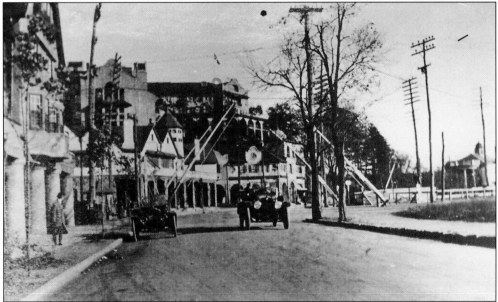

Bronxville's west side Studio Arcade (left, c. 1910) and east side Gramatan Arcade (center) are separated by the railroad track. Studio Arcade was one of the village's earliest multi-use buildings, combining apartments above and shops below. Miss Stretch's private school was also located there.

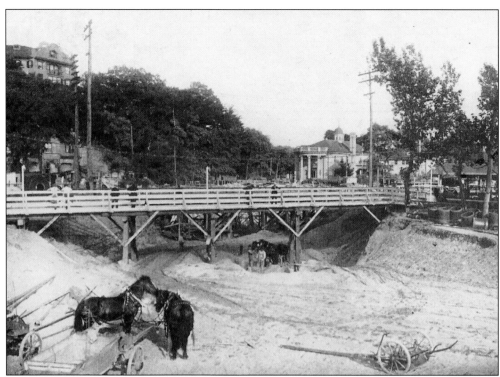

In the interest of pedestrian and auto safety, the present underpass was built at the Bronxville station in 1915–16. With only horse and manpower, construction was a slow process.

Above is a view of a narrow Pondfield Road at Park Place before 1920, when the pace of life was slower. One of the responsibilities of the earliest police was to cut grass growing in the streets. This rare photo shows the old "yellow brick" school behind a house where the 1890s post office once stood.

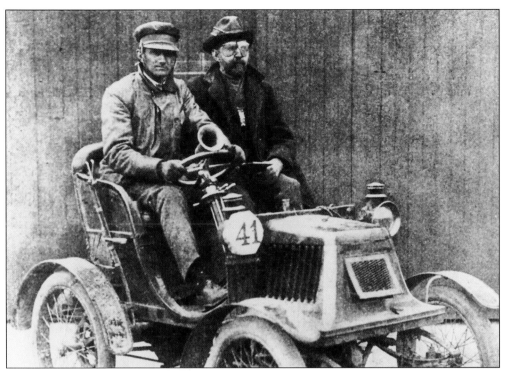

Automobiles, like the "Knickerbocker" manufactured by the Ward Leonard Electric Company, were a major factor in the changing face of Bronxville. Leonard's factory, located on the river site of Swain's mill from 1892 to 1916, built cars for four years after 1899. At the time of his death in 1915, Leonard had more patents on his inventions than Thomas Edison, a friend and former employer who visited the Bronxville factory frequently. Today River House apartments are on the site.

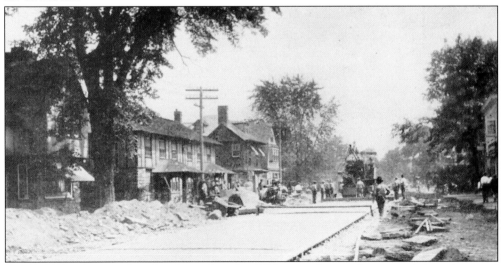

Pondfield Road was widened and paved in the 1920s to make way for automobile parking and commerce. Pondfield, known in the early nineteenth century as Underhill's Road, was primarily a residential street until it was widened. Many old trees were lost, except the one on the left which survived for over thirty more years.

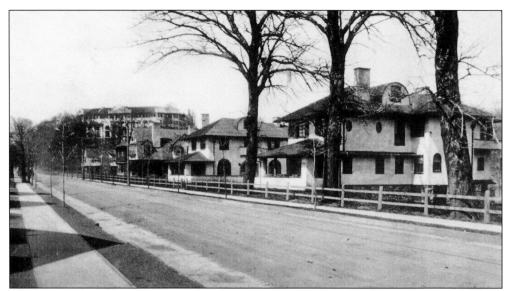

Two views (above and below) of Pondfield Road as it approaches the Hotel Gramatan illustrate the gradual development of Bronxville's main street over several decades. In the photo above, taken before World War I, Pondfield Road is still primarily a residential street. The "twin house" to the left, the last Pondfield Road home to retain its residential appearance, was destroyed by a fire in the 1960s.

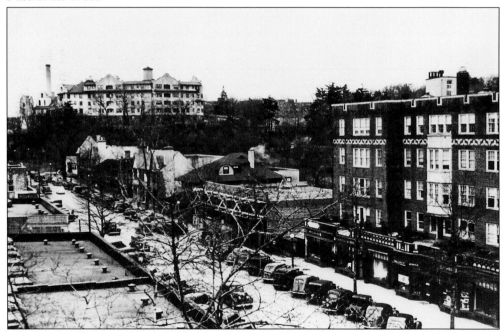

By 1938 Pondfield Road had clearly become Bronxville's major commercial thoroughfare. The six-story Towers Apartments, built above offices and shops in 1927, covered the block from the Park Place intersection to the corner of Tanglewylde Avenue. The Towers, a Lawrence family enterprise and one of several apartment complexes built in or near the business district in the 1920s and 1930s, was convenient for city commuters. Note the last residential house in the middle of the commercial block.

Park Place, looking west toward the railroad, was still a residential street in the 1920s. At the far end stood the huge Gramatan Coal Storage warehouse. The dome of the first St. Joseph's Church appears between the pole and Thomas Phinney's upholstery business.

Park Place, looking east toward Pondfield, gives a better view of the old Catholic church (the reconstructed 1870 school). The McGrath family had a funeral business in the house on the right before the establishment was moved to its present location on Cedar Street.

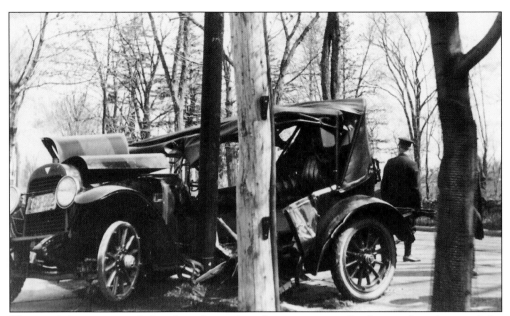

The need for an expanded and swifter police force was partially due to the advent of the automobile. The driver of this wrecked car, who had dined at Siwanoy before going to a speakeasy earlier in the evening, was said to have been intoxicated at the time of his fatal 1920 accident at 119 White Plains Road.

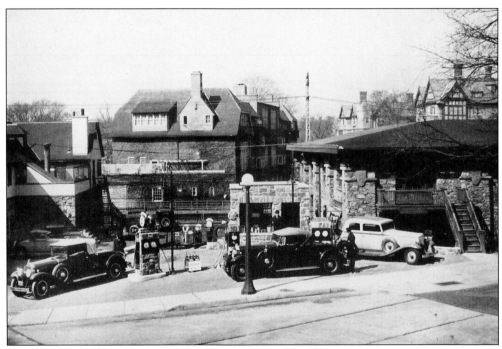

The Kensington Road Service Station, across from the Hotel Gramatan, was conveniently located for Bronxville drivers. This *c.* 1930 photograph shows the office of the local weekly newspaper, *The Review* (right), and behind, across the tracks, are Studio Arcade and the Alger Court apartments.

Mrs. Morgan's Flower Shop on Parkway Road has been a village institution for over seventy years. Pictured here, Emily Wilson Morgan, who founded the shop in 1925, is enlisting the talents of E.A. Frawley, a floral designer. For years, Mrs. Morgan wrote a weekly column about flowers and seasonal arrangements in *The Review*. (MF)

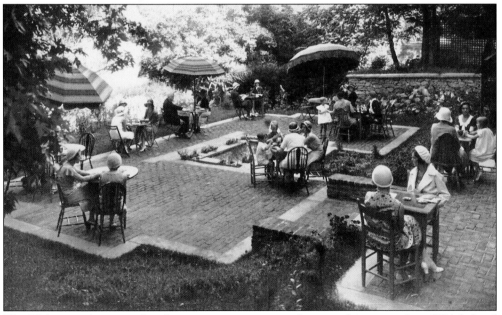

The Helenette terrace, a lovely summer restaurant and tea garden, opened in 1931 behind the pastry and confectionery shop of the same name on Pondfield Road. Tables were arranged around a pool and fountain, and flowering plants noted the names of their donors with small white stakes. Patrons also stopped by for drinks after the theater.

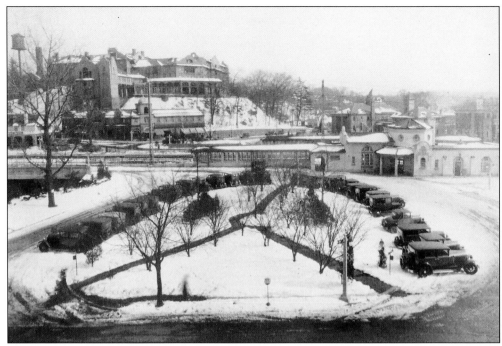

Bronxville's west side station plaza was built in 1916 to accommodate Manhattan-bound passengers. After this photo was taken, the park was enlarged in size and named Leonard Morange Square in honor of a World War I local hero.

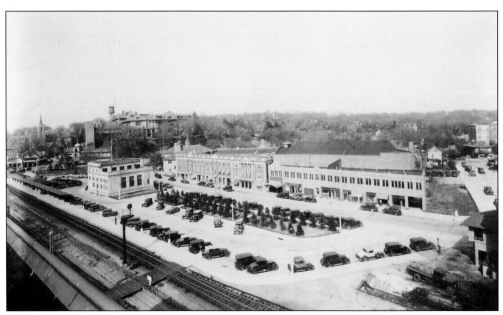

By 1923, Bronxville's small industrial district on the east side of the railroad was replaced by a commercial district of stores and a large parking lot for shoppers and commuters. To the left is the Gramatan National Bank, Bronxville's first banking enterprise. The triangular pediment in the center of the row of buildings sits atop the old picture house, a building that would serve as Bronxville's post office in the 1930s.

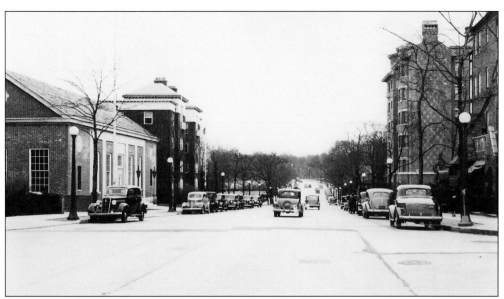

By the 1930s, Bronxville's postal district, which includes parts of Yonkers and Eastchester, had outgrown the several small buildings that had served as post offices since the 1800s. The interior of the present 1938 building (far left) contains John Sloan's WPA mural depicting Bronxville's early railroad history. The three other buildings are apartment houses.

The construction of the present public library, located at Bronxville's "four corners," became a necessity after the floor of the first library in old village hall began to sag under the weight of the collection. As shown here, c. 1943, the red brick Georgian building is also the site of many community gatherings.

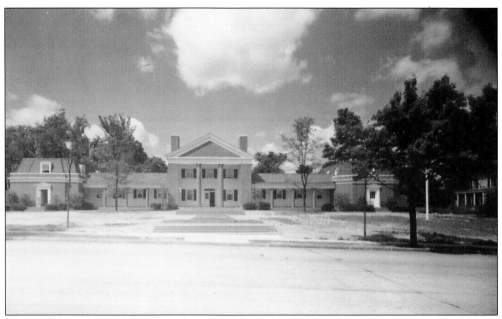

This stark early view of the new village hall, also located at the "four corners," was taken shortly after the building's completion in 1942. Note the porch of the Reformed Church parsonage (right), located between Village Hall and Midland Avenue until the manse was razed in 1945.

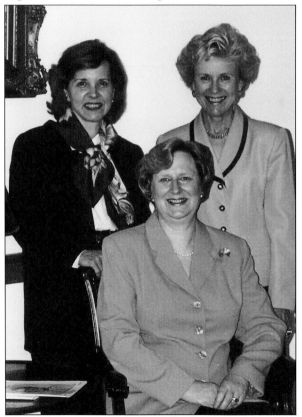

Serving as Bronxville's mayor during the 1998 centennial is The Honorable Nancy D. Hand, seated. For its first eighty years, Bronxville's top office was occupied by male volunteers only. This tradition was broken in 1977 when Marcia M. Lee (left) was elected to her first term. From 1987 to 1993, Sheila S. Stein (right) held the office. Mayor Hand is serving her third two-year term. (AU)

Four

Religion in Bronxville:
Keeping the Faith

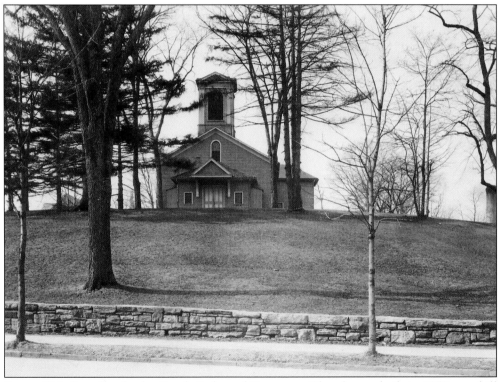

Bronxville's first church, the Dutch Reformed Protestant Church, was built in 1850 on a hill overlooking the community's few businesses and homes. Early settlers Masterton, Prescott, Swain, and Bolton donated their talents, resources, and land to insure that religion would be part of village life. Mid-century services had to be held on Sunday afternoons, since the congregation shared their minister with a church in Greenville. The belfry remained empty until Sunday school children raised enough money to purchase a bell in 1872.

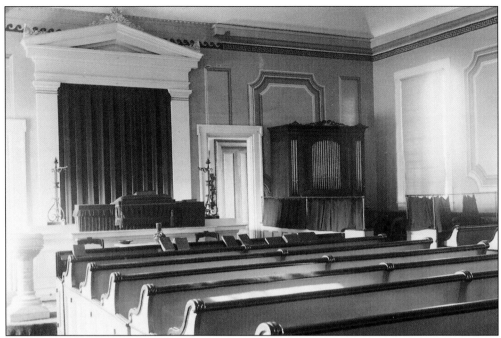

The Reformed Church's interior, like its exterior, exemplified the simplicity of New England Protestant church architecture. At right in this 1873 photo is an organ donated in 1870 by Alexander Masterton Jr. over the protest of James Prescott who believed "mechanical music" was the "work of the devil." Masterson's teenage daughter Louise was the first church organist.

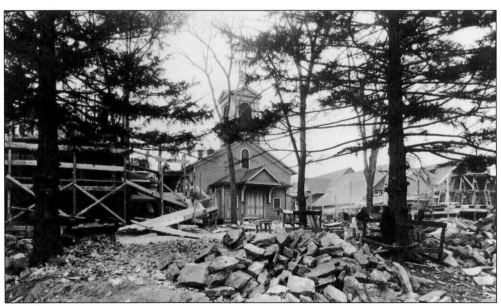

By 1925, the Reformed congregation outgrew its modest sanctuary. Before construction could begin on a new church, a nineteenth-century burial ground had to be removed from the hillside. The remains of sixty graves were interred in a vault under the new church nave. Services continued in the old frame church while the new edifice was built around its three sides. The final destruction of the 1850 building created space for the beautiful cloister.

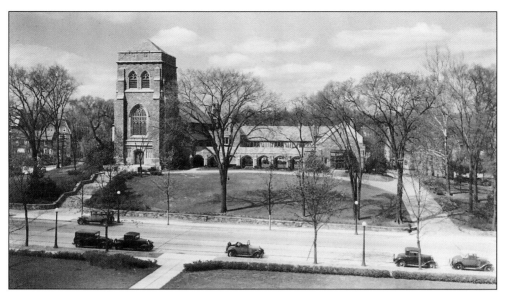

This imposing stone structure, completed in 1926, was designed by village architect Harry Leslie Walker. Music from bell chimes installed in the tower has been played before each Sunday service since.

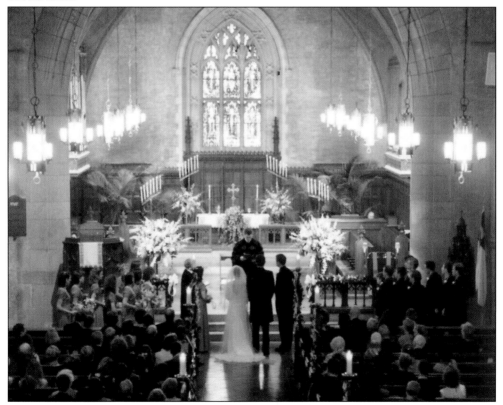

The impressive interior of the Reformed Church, especially its stained-glass windows, has enhanced the dignity and beauty of its services. The splendid organ has four keyboards and over 4,200 pipes. (CK)

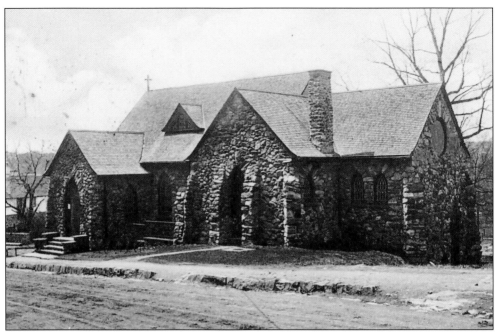

Bronxville's second church was the Episcopal Christ Church. The first recorded Episcopal services in Bronxville were held in 1898 for summer residents at the "Casino." In 1900 this "mission" congregation moved to the second floor of Pick's general store. The group incorporated as a parish and the fieldstone church (above) was built in 1901. Though not a member of the congregation, William Lawrence donated the land for the church and a parish house. In the early 1960s, the church columbarium was established on this site.

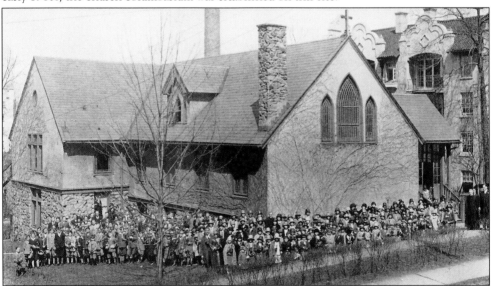

The first parish house was built in 1908 next door to Christ Church on Sagamore Road. The structure contained Sunday school classes, pictured here in 1925. During the influenza epidemic of 1918–1919, it served as an infirmary for the overflow of patients from nearby Lawrence Hospital. In existence for seven weeks, the hospital annex treated 150 patients, 17 of whom died.

By the twenties, the Christ Church congregation had outgrown its building and in 1926 a new church was constructed on the site of the parish house. Designed by architect Bertram G. Goodhue, the Gothic-style structure and its dramatic steeple (pictured here from Kensington Road in 1926), redefined the Bronxville skyline. Christ Church has maintained its ties to Bronxville's early founders through Lawrence family descendants.

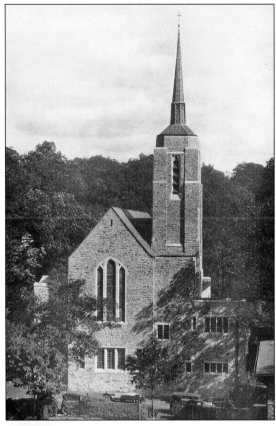

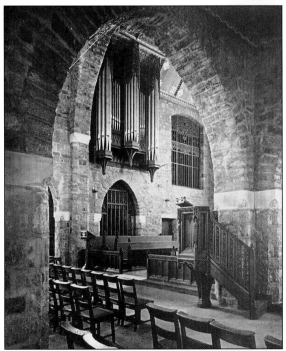

A focal point of the interior of Christ Church is its fine organ, a source of the church's well-known liturgical music program. Wooden chairs in place of pews have contributed to the stark simplicity of the beautiful building for over seven decades. Because the church was located within the shadow of Lawrence's Hotel Gramatan, it traditionally welcomed guests from the hotel as well as worshippers from nearby communities.

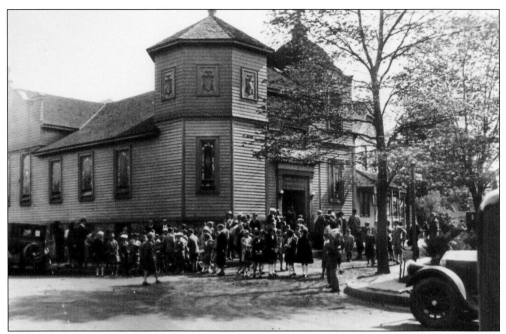

About seventeen families celebrated Bronxville's first Catholic services in 1905 at the Hotel Gramatan. The next year, Bronxville's thirty-five-year-old vacated schoolhouse was purchased by the Catholic community and moved around the block from Pondfield Road to the corner of Park Place and Kraft Avenue (above, *c.* 1920). That remodeled building became St. Joseph's Chapel, a mission of the Tuckahoe Parish. (SJ)

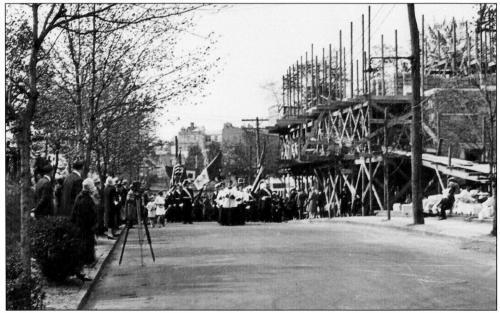

In 1922 St. Joseph's became a parish and its congregation grew so rapidly that within five years a new structure was needed. Construction began on a new building at the corner of Kraft Avenue and Cedar Street, and in 1927, amidst much pageantry and celebration, the new church was dedicated. (SJ)

St. Joseph's English Gothic Revival church, completed in 1928, was designed by architect William H. Jones of Yonkers. It is constructed of stone from Westchester County quarries. In 1951 a parochial school was completed beside the sanctuary on the corner of Kraft and Meadow Avenues, and in 1986 a new parish center was built to replace a Meadow Avenue house that had served as a center until that time.

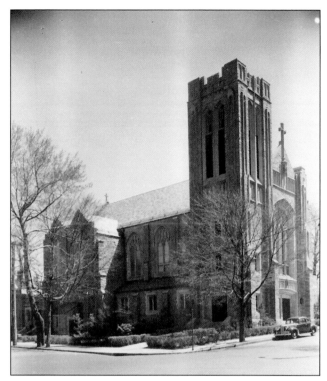

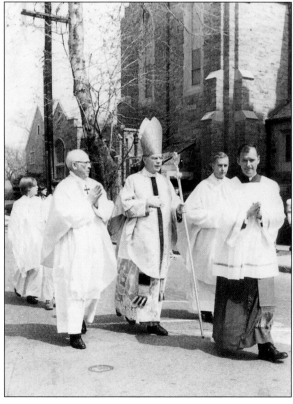

St. Joseph's parish has risen in prominence within the Archdiocese and, on occasion, such as the 1972 Golden Jubilee Celebration (left), dignitaries from the broader Catholic community have added stature to local festivities. Pictured from left are Monsignor Joseph Moore, His Eminence Terence Cardinal Cooke, Father John Houlihan, and Monsignor Theodore E. McCarrick, presently Archbishop of Newark.

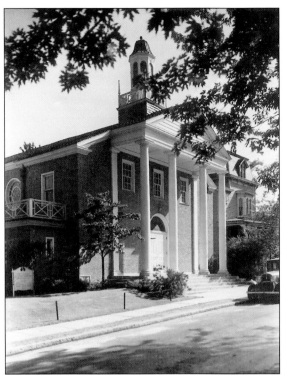

In 1915 a group of Bronxville residents organized a Christian Science Society, and for ten years they held services in rented space in the old village hall. The First Church of Christ, Scientist, formally incorporated in 1920, purchased land at the corner of Tanglewylde and Garden Avenues. In 1925 the church's east wing was built, and the main auditorium, designed by architect Bernhardt Muller, was added in 1929. Next door is the old A.E. Smith house, razed c. 1930. (CSC)

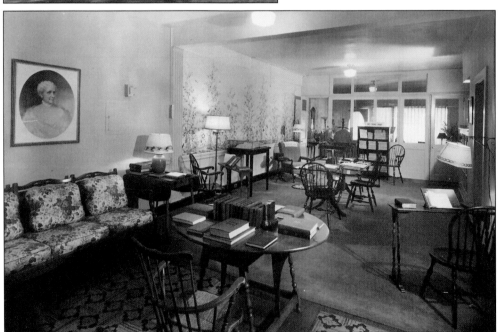

Central to the Christian Science faith are public reading rooms. Bronxville's first reading room was opened in 1919 in a small space above the fire station in the old village hall, and six years later it was moved to the new structure at Garden and Tanglewylde. In 1943 the room above was opened at 60 Pondfield Road. Here, until 1988, one could read under the pleasant gaze of the church's mid-nineteenth-century founder, Mary Baker Eddy. (CSC)

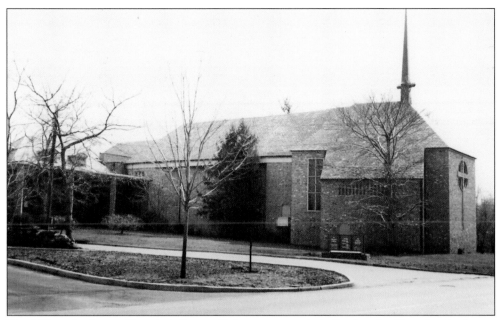

The Village Lutheran Church is Bronxville's most recently built church. Though a Lutheran congregation was organized for Concordia College students and faculty in 1916, a church serving the broader community was not established until the 1940s when services were moved to a private home across the street from the campus. The present church was built on that site in 1950 and was the design of architect Perry M. Duncan.

Hidden in a quiet corner of the village is Bronxville's small, one-acre cemetery. This interdenominational burial ground, owned and operated by the Reformed Presbyterian Church in New York City, was established in 1851 when many urban churches sought inexpensive rural land for cemeteries. Each year part of the Memorial Day service is commemorated here.

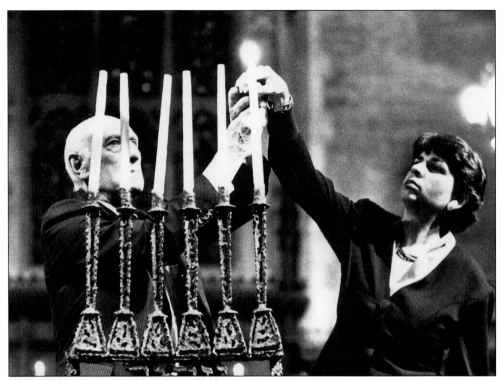

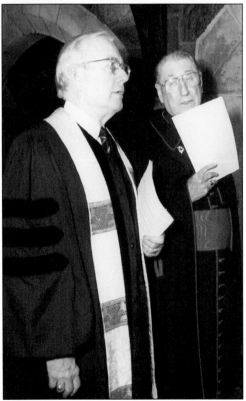

The lessons of World War II's holocaust made Americans of all faiths more conscious of the extremes to which bigotry and hatred could be taken. In 1991 Bronxville's Reformed Church, in cooperation with the area's other churches and synagogues, initiated an ecumenical Holocaust Service to use lessons of the past to enlighten our future. Pictured above, lighting a candle at the 1991 service, are holocaust survivor Jack Polak, and Judge Ingrid Braslow, who was a grandchild of holocaust survivors. (JP)

In 1996 the fifth Westchester Holocaust Service was again held in Bronxville's Reformed Church. Shown at left at this service are host minister, founder of the first service, and member of Westchester's Holocaust Commission, Reverend P.C. Enniss, and His Eminence John Cardinal O'Connor of the New York Catholic Archdiocese. (GN/SH)

Five

Education:
"The Very Cornerstone of Our Community Structure"

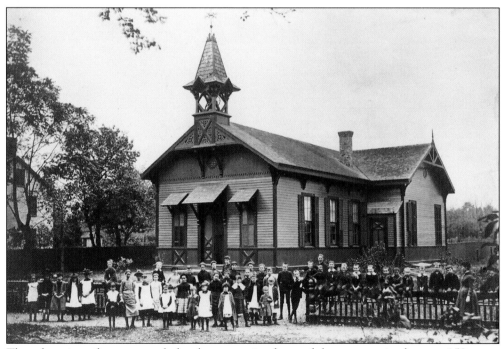

The education of young people has been a major focus of the community for over 150 years. Although there have been small private schools scattered throughout the area, villagers have believed in the importance of a quality public education. The first village public school was built in 1870 (shown above *c.* 1890). Two years later, in pleading for a significant budget increase for the district, school board president Robert Masterton noted that education was "the very cornerstone of our community structure."

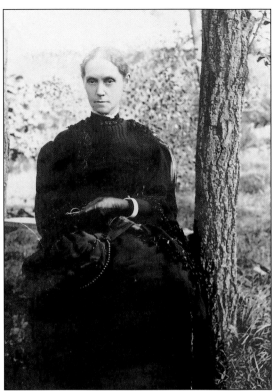

Miss Martha Prescott Lyman, a niece of the Swain family, was a college graduate and the village's first schoolteacher. She started a private one-room school in 1853 behind the Reformed Church, and later moved the classes to her home nearby. She was remembered as a "firm but gentle New England school mistress" who made sure that Bronxville's young students learned the "three R's."

The Marble School, built in 1835 of marble from Alexander Masterton's Tuckahoe quarry, stood on White Plains Road in Mount Vernon where it served children from neighboring communities until 1869. It is shown just after being moved, stone by stone, to California and New Rochelle Roads in Chester Heights, where it has been restored by the Eastchester Historical Society.

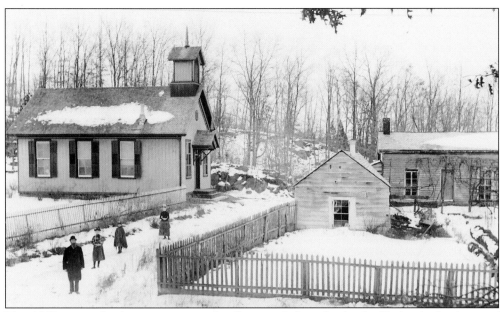

This 1880s view of a classic one-room schoolhouse is believed to be the Yonkers' school west of Bronxville that became known as Public School #8 Annex, or the Lockwood Avenue school. It was common in the nineteenth century to have many small schools serving a rural area.

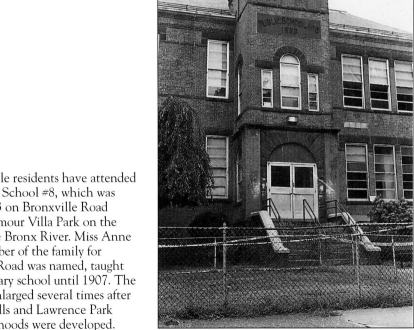

Many Bronxville residents have attended Yonkers Public School #8, which was erected in 1893 on Bronxville Road adjacent to Armour Villa Park on the west side of the Bronx River. Miss Anne Palmer, a member of the family for whom Palmer Road was named, taught in the elementary school until 1907. The building was enlarged several times after the Cedar Knolls and Lawrence Park West neighborhoods were developed.

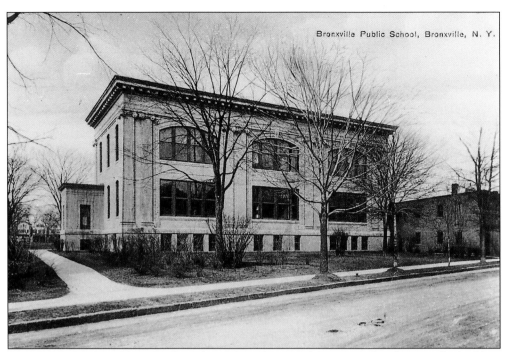

The "yellow brick" public school was located on the site of the 1870 schoolhouse. The building had two entrances—south for boys and north for girls. Between 1906 and 1924, there were individual classrooms and a full course of study for grades one through eight.

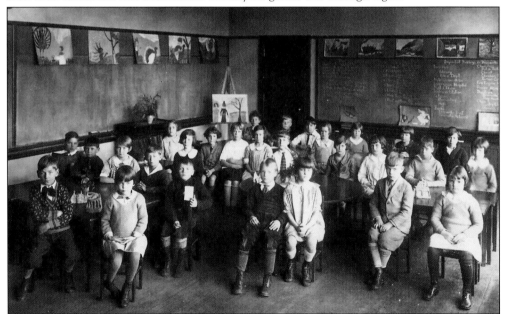

This c. 1920 Bronxville classroom scene would indicate that students "sat perfectly still reciting, memorizing, and doing assignments," as one former student claimed. Each school day began with a prayer. The community grew so rapidly in the 1920s that a third new school building was required. This enabled Bronxville to house the entire school population on one campus and to expand its sports program.

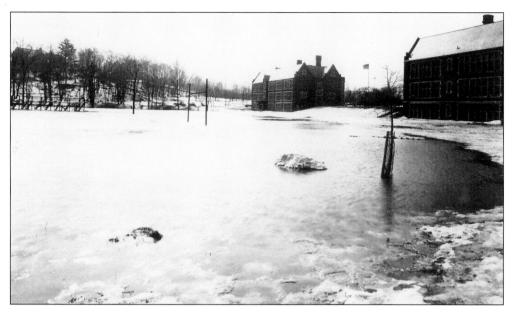

Choosing a location for the new school prompted a bitter debate: the Hemlock Road hillside or the "pond field" where there was space for athletic fields. The latter was chosen, the swampy land drained, and in 1924–25, two red brick buildings were erected. Ground water and flooding have plagued the school ever since, although the central location has been ideal.

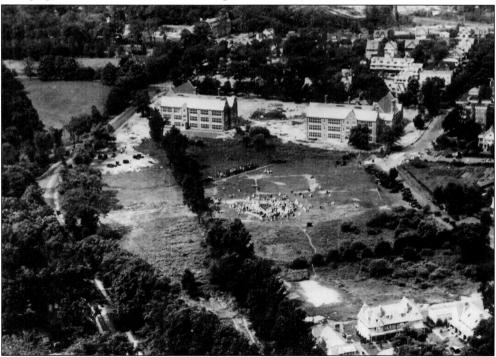

This aerial view of the twin schools taken during the Defense Day Assembly on July 4, 1925, by the U.S. Army shows the school field bisected by trees growing from the flood control area of the Midland Avenue drain. There was no public library or village hall (upper left), and the Reformed Church was still a small wooden building.

In 1930, with the addition of a central building connecting the two separate red brick wings, the expanded Bronxville School could accommodate students from kindergarten through senior high. Several outstanding administrators, including Willard Beatty and Julia Markham, introduced a new less rigid and more individualized philosophy of learning known as progressive education. Highly skilled educators have been attracted to the community ever since, and the school remains a major draw for families.

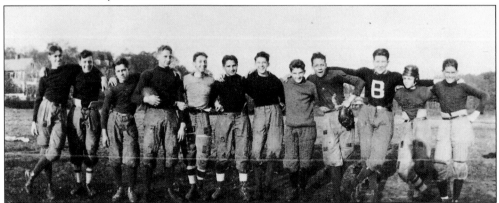

The school sports program grew dramatically in the 1920s after the high school was built on the new campus. Up until that time, students shared facilities with local private schools. In spite of a limited sports program, Bronxville football teams defeated major rivals in the early 1920s. As the above photo illustrates, less emphasis was placed on uniforms or padding in those days. Lifelong resident Lewis Griffith is fifth from the right.

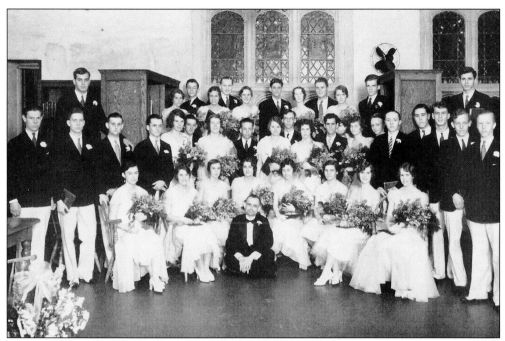

Women of the graduating class of 1930 were formally attired in traditional white dresses and carried large bouquets. The men wore dark jackets with white slacks, the reverse of their attire in later years. The school library's beautiful Gothic stained-glass windows, depicting sixteenth-century printers' marks, were made initially for the Sterling Memorial Library at Yale. The school purchased the extra panes Yale was unable to use. Popular teacher I.D. Taubeneck is seated in the front row.

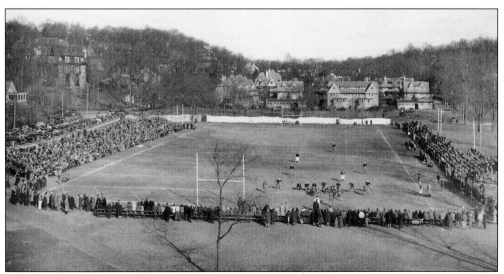

This 1931 Thanksgiving Day game between Bronxville and the Hackley School was a benefit for the Depression-era Unemployment Fund. The football field is running north and south, or perpendicular to today's field. In the late 1930s, Chambers Field was built to the northeast along Midland Avenue with labor provided by the New Deal's WPA. Field Court townhouses can be seen in the background.

The private Brantwood Hall School, established in 1906, was a country-day, boarding, and finishing school for kindergarten through twelfth grade. Established by Arthur Lawrence, it was located in the Tanglewylde and Woodland Avenues area. The school closed in the late 1940s, and the buildings became private homes.

Though primarily a girls' school, the Brantwood student body expanded to three hundred after boys were admitted. The youngsters at play, c. 1930, look like fashionable miniature adults in woolen top coats, caps, and cloches.

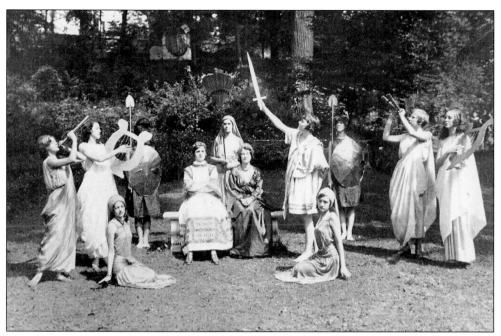

Brantwood Hall's curriculum emphasized drama, literature, and languages. The upper school included girls from all over the world and performances were often given in foreign languages. Here a scene from the Greek pageant *Theseus* is presented outdoors in June 1930.

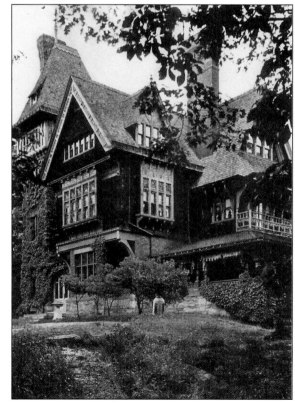

From 1908 to 1920, the Massee Country School was in operation in the former home of Alexander Masterton Jr. on Hemlock Road. This primary and secondary boys' institution, which replaced the Blake School, was founded as a college preparatory school. It was both a boarding and day school for sons of prominent families, and students were required to bring patent dancing shoes.

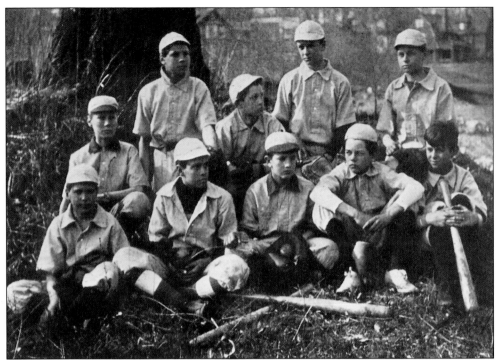

As a part of a program for developing the well-rounded man, the Massee School offered a diverse sports program. Members of the baseball team are shown here in a pose reminiscent of the "Little Rascals."

The location of the Massee School at the top of a hill made its grounds an excellent course for sledding. Notice the 8-foot-long wooden sled.

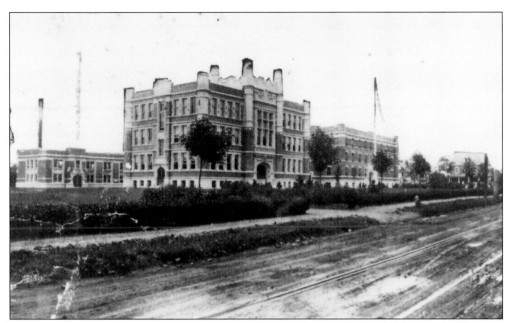

Concordia College, a Lutheran men's junior college and senior high school, was already in its third decade in 1909 when the campus was relocated in Bronxville and the administration and classroom buildings (above) were constructed on White Plains Road. (CC)

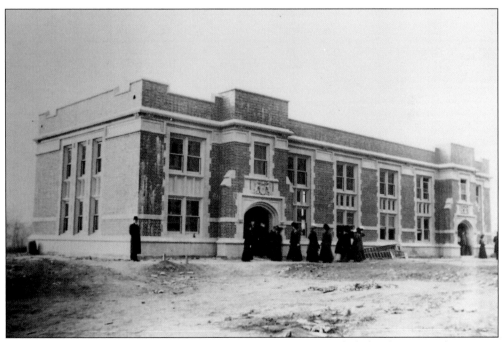

A separate dining hall, the "Commons," was constructed behind Concordia's main building. Here, community members walk across the muddy lawn at the 1909 dedication of the dining hall. Over 2,500 people attended the ceremonies dedicating the first three campus buildings. (CC)

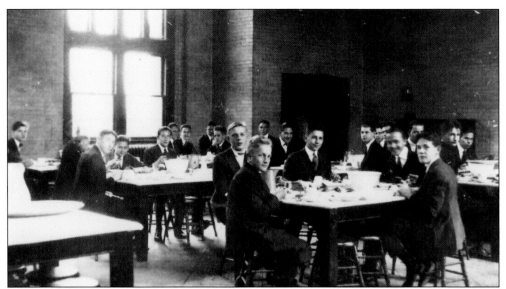

Some of Concordia's early students are enjoying a meal in their new dining hall. A school brochure advertised life on campus as "plain living, no luxuries." Until 1939, Concordia had only male students, many of whom were preparing for the ministry. (CC)

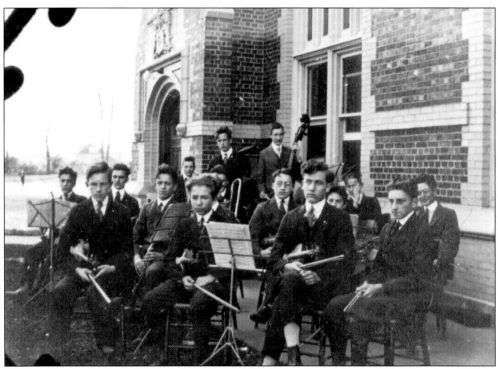

A Concordia student musical ensemble performs in front of the college, c. 1918. Its first musical groups, an orchestra and a chorus, were founded in 1914. In the years before the World War I, because of Concordia's affiliation with the Lutheran Missouri Synod, German was the primary language of instruction. (CC)

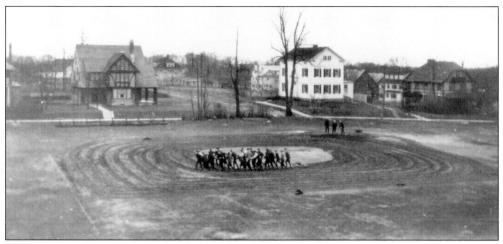

Sports have been an important part of student life at Concordia despite the soggy conditions of the sports field on Tanglewylde Avenue (c. 1915). Students described the area around campus as having plowed fields with roaming cattle. The 14-acre campus was purchased from the Lawrence family. (CC)

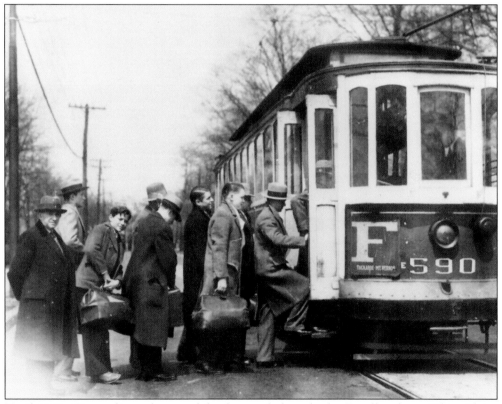

Until 1932, Concordia students and faculty regularly rode the F-trolley down White Plains Road to Mount Vernon, or further into the city. Students nicknamed the trolley cars "Tuckahoe Gondola," "Old Ferry," and "Toonerville Trolley," and complained that they creaked and groaned and were always late. Bronxville's trolleys ran along Midland and Gramatan Avenues as well as White Plains Road. (CC)

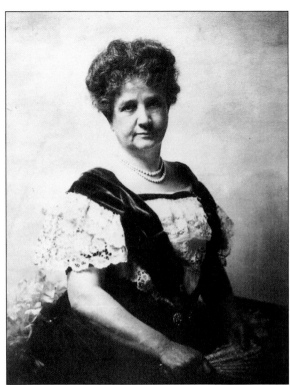

Sarah Bates Lawrence, whose husband established Sarah Lawrence College in her memory, is shown here around the turn of the century. Though she was not college educated, Mrs. Lawrence believed strongly in women receiving higher education. During her later years she was a generous supporter of the Bethune-Cookman College for Negroes in Daytona Beach, Florida. Sarah Lawrence College, at first a junior college for women, opened in the fall of 1928 with 150 students from 27 states. (SLC)

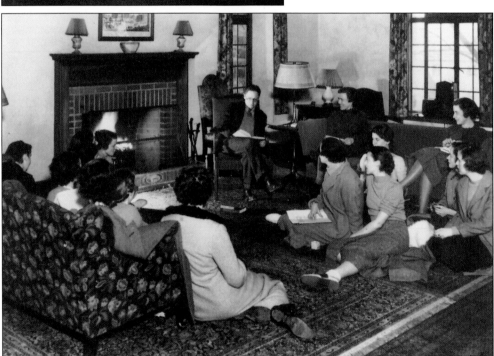

Professor Horace Gregory, a well-known poet, is shown with students during the "poetry hour." One of the college's three stated goals at its founding was "to stimulate an intellectual interest in women that would be an animating principle throughout their lives." (SLC)

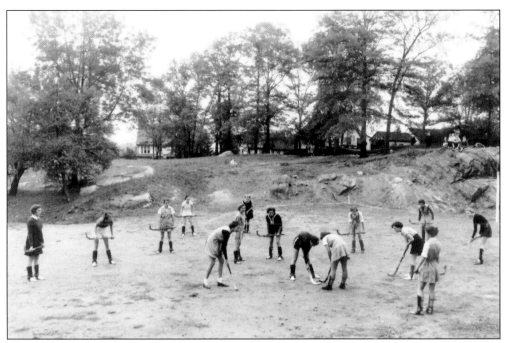

Field hockey, a popular Sarah Lawrence sport, is played on the school's ungraded field shortly after the college opened. A second goal of the college was "to graduate women whose experience in group activities has shown them the value of co-operative effort." (SLC)

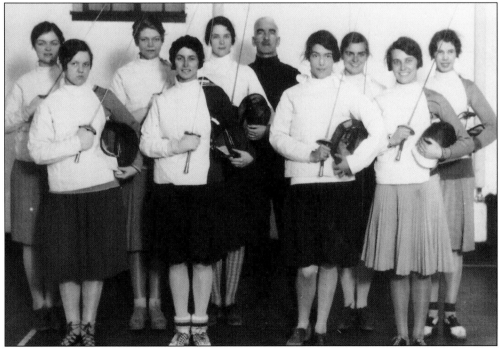

Lawrence intended the purpose of the college to be "cultural as opposed to professional." One assumes the young women who learned fencing under the stern direction of Capt. McPhearson considered their training to be "cultural as opposed to professional." (SLC)

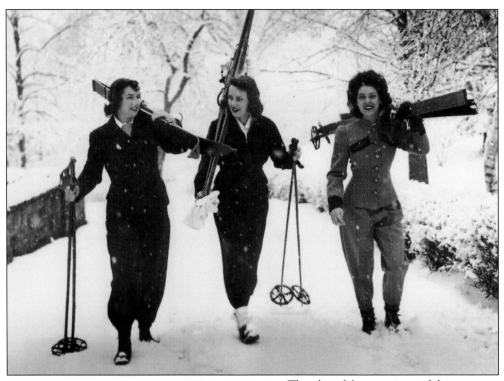

The cheerful expressions of these fashionably dressed skiers, *c.* 1940, seem to indicate that skiing was a popular form of recreation at Sarah Lawrence, though it was not an official school sport. (SLC)

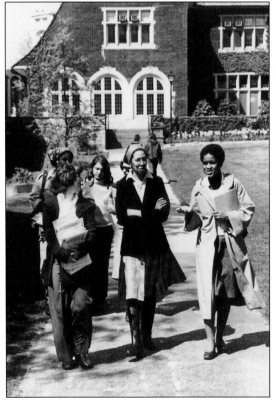

During its early years Sarah Lawrence's reputation as an excellent liberal arts college attracted a homogeneous student body of bright privileged women. For a few years after 1946, Sarah Lawrence was temporarily a co-ed school while veterans attended classes on the G.I. Bill. Since the 1960s the college has made an effort to diversify its talented student body, including the admission of men after 1968. With its "don" system, it has continued to place emphasis on individual attention to each student. (SLC)

Six

A Fashionable Suburb:
"Endlessly Copied but Never Matched"

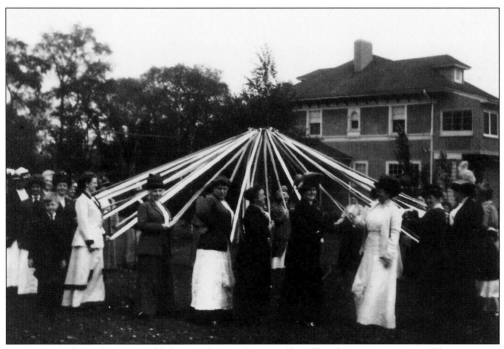

At a time when the pace of life was slower, Bronxville offered a gracious way of living to its residents. Visits from friends and social gatherings, as well as seasonal events such as this c. 1910 weaving of the Maypole, were occasions to be anticipated and enjoyed. The village has been able to maintain an enviable small-town charm, thus prompting urban historian Kenneth Jackson to state that Bronxville has been "endlessly copied but never matched."

Louise Masterton (*c.* 1870), daughter of Alexander Masterton Jr., is said to be Bronxville's first debutante. She later reminisced, "My Calico Ball was one of my dearest remembrances. The home was filled with flowers sent by friends and relatives . . . The servant announced the arrival of Mr. Swain Jr., and there he stood bowing with a strip of my calico sewed down the side of his pants to match my dress . . . By 8 o'clock about 60 guests were assembled and the dance started and everyone was merry. Musicians and the caterer were from New York . . . It was all too romantic."

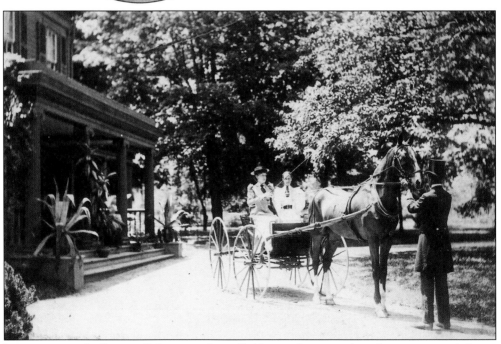

It was common for Bronxville homes to be staffed by coachmen, such as the one pictured above, as well as cooks, maids, gardeners, and governesses. Victoria Ridgway (in hat), with a friend, prepares to go riding around the village, *c.* 1890. She was a published songwriter and poet.

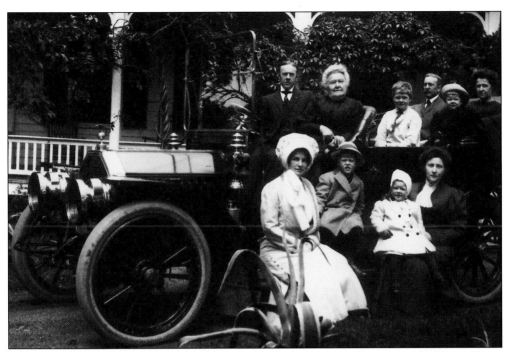

Sarah and Daniel Hopping moved a mile or so north from Mount Vernon to 129 White Plains Road in 1909 with their young children, Dan and Margaret, who are seen here perched on the running board of the splendid family auto. Young Dan attended the Massee and the "yellow brick" schools before graduating in the first class of the Bronxville School in 1923.

The Hopping home (c. 1910), named Innisfree, was a handsome four-square house with porches, a porte cochere, and a garage. Families from more densely settled neighborhoods like Mount Vernon were attracted to Bronxville where they could purchase large new homes with broad front lawns.

Madame Victorine Carmody and her husband, William Carmody, bought a large home on White Plains Road. After immigrating as a governess from France in 1867, Mlle. Victorine repaid her employer her passage and went on to become a very successful society fashion designer in New York. Note her cinched waist, a "must" for a fashionable young woman of the time. (VG)

The Carmodys' home, Mon Plaisir, comprised the old Morgan-Underhill house remodeled with a sweeping columned porch and additional rooms. Here the Carmodys entertained prominent New York City friends, especially those from the music world. The house is now Stein Hall on the Concordia College campus.

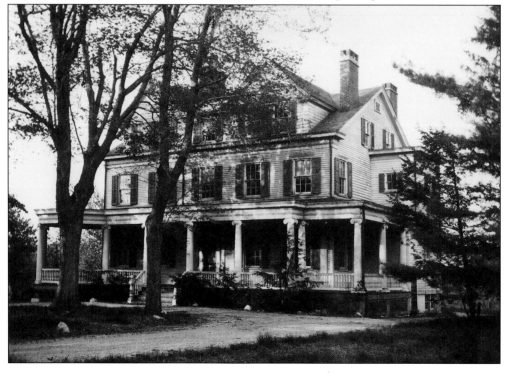

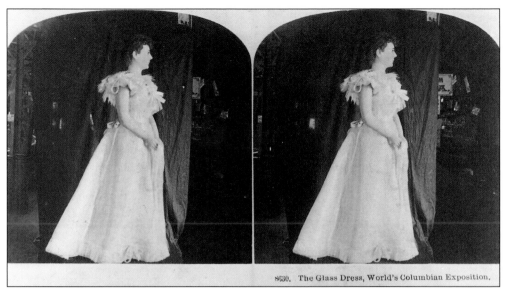

The model on the stereograph card from Chicago's 1893 World's Columbian Exposition is wearing a spun glass dress designed and exhibited by Madame Victorine. Seamstresses were hesitant to work on the dress because tiny glass splinters lacerated their fingers. Madame Victorine gained particular fame when her glass dress was worn by a Spanish princess. (SS)

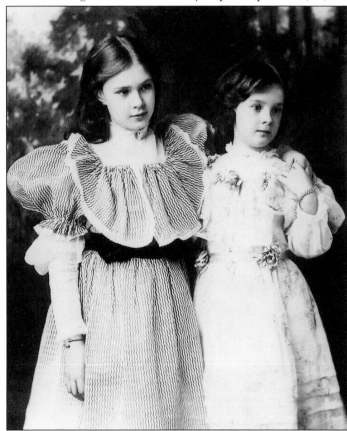

The Carmody daughters, Florence and Adele, pose in their exquisite dresses, probably made at home by their resident seamstress, Helen. Since Madame Carmody was a famous couturiere (her label read "Madame Victorine"), she most likely designed her daughters' dresses. Both Carmody daughters lived in the Bronxville community as adults.

91

Jerome Kern and his wife, Eva, moved to Bronxville in 1917 after his musical career blossomed on Broadway. The show *Love O' Mike* poked fun at the Bronxville Fire Department which had belatedly switched from horse-drawn vehicles to gasoline engines. Satirized fire department members were Kern's guests at the show. Kern contributed generously to bond drives during World War I and organized local war memorials.

The Kerns rented their first local home at the corner of Sagamore and Avon Roads, and later invested in the Sagamore Park residential community nearby. Bypassers reported hearing Kern at work on such musicals as *Have a Heart* and *Oh Boy*. He composed at a custom-designed desk attached to his piano. (BL)

The Kerns bought land on Dellwood Road in the Cedar Knolls area of Yonkers and built a large home with a library for his rare book collection. With the birth of their only child, Elizabeth Jane, they wanted more land to keep small farm animals to remind Mrs. Kern of her childhood in England.

In 1922, daughter "Betty" Kern (back row, third from left) posed with friends for her fourth birthday party at their Cedar Knolls home. Soon after, the Kerns moved to Hollywood.

The architect Lewis Bowman and his wife, Eleanor, moved to Bronxville in the early 1920s. Today, Bowman is Bronxville's most well-known architect because of his custom-designed mansions. His versatile architectural designs, which included Tudor, Georgian, Mediterranean, and Colonial Revival styles, catered to the tastes and aspirations of a community inhabited by affluent executives and professionals. Bowman constructed more than sixty homes in Bronxville. Though his business flourished during the 1920s, he suffered considerable financial loss in the Crash of 1929 and his practice never fully recovered. (FB)

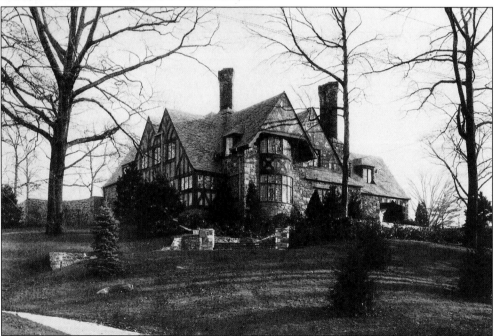

Bowman's eclectic English Revival style, often termed "stockbroker's Tudor," mixed details from many periods as shown in this 1920s home at 6 Beechwood Road. Landscaping and setting were as important to Bowman as architectural design.

Bowman demanded first-rate craftsmanship and materials in his homes. His attention to fine details, such as the leaded windows, half-timbering, and clustered chimneys pictured in this 1920s home at 31 Masterton Road, have given his houses an enduring quality.

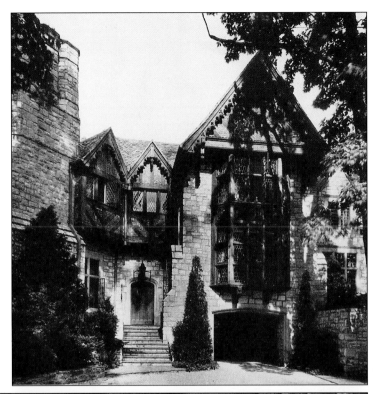

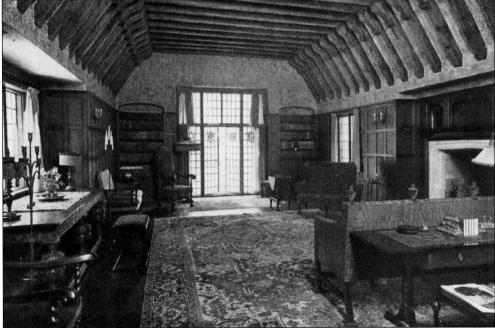

The interior of this Bowman house at 9 Elm Rock Road is typical of Bowman's designs. The beamed ceiling, fine wood paneling, and multiple fireplaces added elegance to his homes. Lewis and Eleanor Bowman often decorated the interiors with antiques, oriental rugs, and period reproductions for the owners.

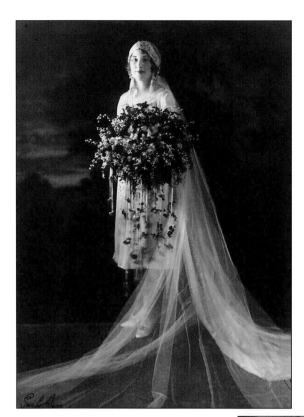

The wedding of Bronxville residents Jane Gray and Elliott Bates was a major social event in the fall of 1926. Bates, a World War I veteran, was awarded the Croix de Guerre for his distinguished service in France. He became a successful realtor and was a founding governor of the Field Club. Jane Bates was active in civic and church affairs. The couple resided all of their married life in the village, and descendants still live here. (EB)

Another 1920s bride, Margaret Bailey, bride of E.S. Clark, epitomized the fashion-conscious woman of the 1920s. Like Miss Gray, she wore a short, flapper-style gown, but retained the traditional long-trailing veil of earlier brides. Miss Bailey was a twin, and her mother, Gertrude Stein Bailey, was a concert singer.

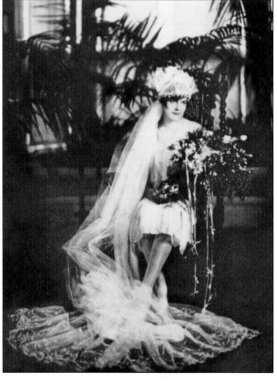

Mary Legget Young (Purdy) and her son, Roger A. Young Jr., were residents of Oakledge through the 1930s. The Leggets had purchased the mansion from the estate of John Masterton in 1888, and Mary Legget continued to live in the home during her marriage. Mrs. Young was widowed in 1932 and later remarried, becoming Mrs. A.J. Purdy. She is remembered as a generous philanthropist.

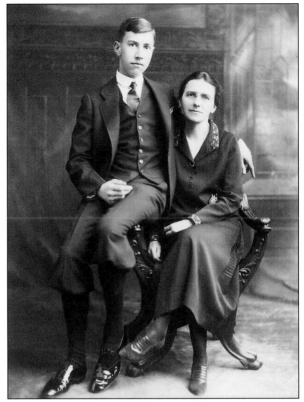

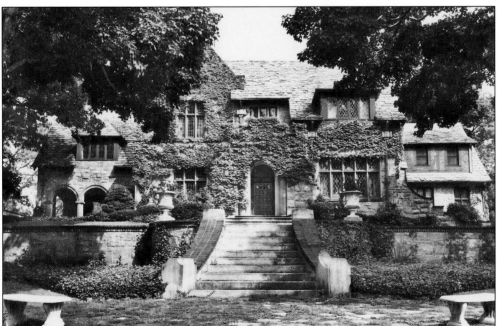

The 1870 Victorian house, Oakledge, was completely renovated into a Tudor mansion in the 1920s by Lewis Bowman. During World War II, Mrs. Young/Purdy turned the house and other estate cottages over to the American Red Cross to use for the war's duration.

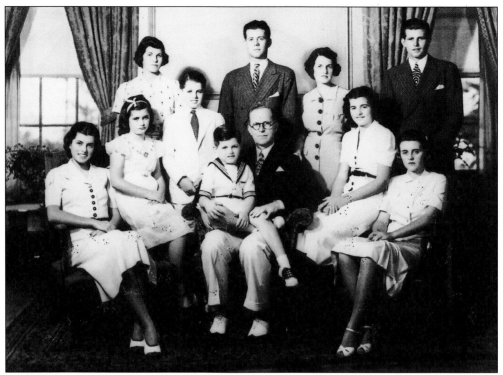

The Joseph P. Kennedy family is photographed in their Bronxville home at 294 Pondfield Road in 1938. The family resided in Bronxville from 1929 to 1938 before moving to London. They sold the home in 1941. Future President John F. Kennedy is in the center. (JFK)

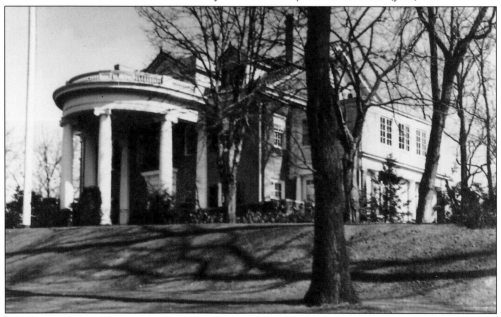

The Kennedy family lived for almost ten years in Crownlands, their imposing red brick residence. Though they were not intimately involved in the Bronxville community, the family belonged to the Field Club and the Siwanoy Country Club.

Rose and Joseph Kennedy pose outside their Bronxville home on Christmas Day, 1933. Most winter holidays were spent in Palm Beach, Florida, and in the summers, the family stayed in Hyannisport, Massachusetts. While in residence in Bronxville, Kennedy was involved with the movie and film industry, in addition to other financial concerns, and was the first Chairman of the SEC. In 1938 Kennedy was appointed Ambassador to England by President Roosevelt and the family left Bronxville. (JFK)

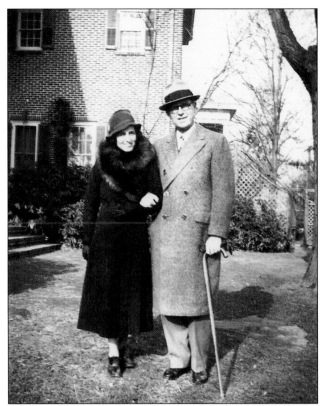

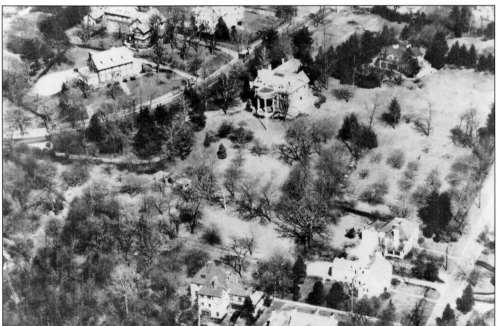

The Kennedys' 5.5-acre estate is shown here with Pondfield Road on the left. In the 1950s the mansion (top center) was torn down and the estate subdivided into small lots that have since been developed.

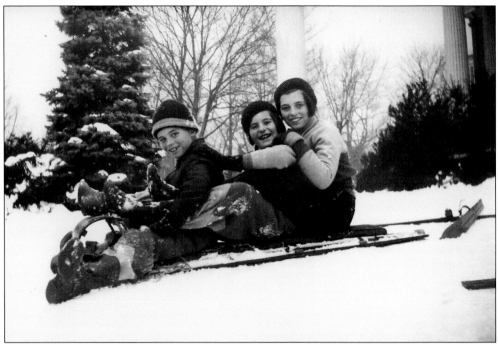

Bobby, Pat, and Eunice Kennedy are shown sledding on the front slope of their Bronxville home. The Kennedy children also sledded on Young's Hill at neighboring Oakledge. Six of the Kennedy children attended Bronxville schools intermittently between 1929 and 1938. (JFK)

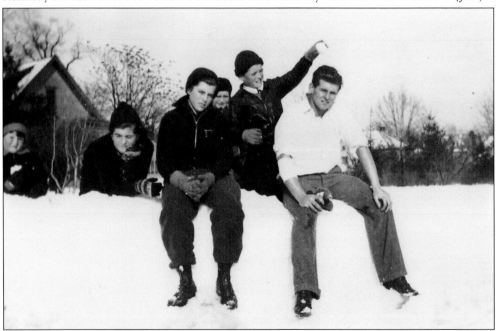

Six of the nine Kennedy children are shown enjoying the snow and warm weather on the lawn of their home. From left to right are Teddy, Pat, Eunice, Jean, Bobby, and Joe. Teddy, the only Kennedy born while the family resided in Bronxville, had his early schooling in a private school in Lawrence Park West. (JFK)

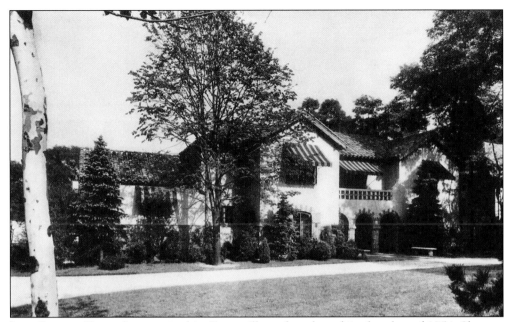

Joan Bennett Kennedy was raised in Bronxville and graduated in the class of 1954. She was assistant editor of the school newspaper and an accomplished pianist. Before her marriage to Ted Kennedy, the family moved into this Mediterranean-style Bowman house at 14 Eastway. The first owner of the home was James Black, future father-in-law of Shirley Temple Black.

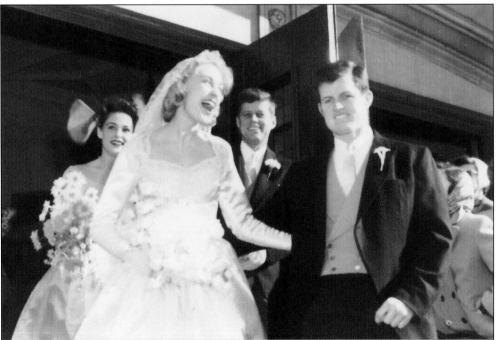

Bronxville's 1958 wedding of the year was that of Joan Bennett and Ted Kennedy at St. Joseph's Church. Brother John Kennedy, as best man, and sister Candace Bennett, as maid of honor, are shown in the background. The reception was held at Siwanoy. Though bride and groom had both lived in Bronxville as children, their paths did not cross until later. (MF)

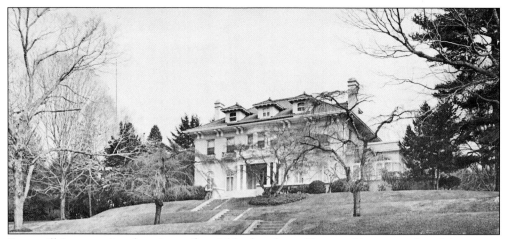

Bronxville's convenient location, safe neighborhoods, and large residences, such as this twenty-three-room, 2.65-acre estate at 283 Pondfield Road, are some of the reasons members of the international and diplomatic communities have chosen to live in the village. In the 1980s, Morocco's King Hassan II bought this home for his daughter, Princess Lala Merian. The home was later sold to artist-businessman Noriyoshi Ishgooka of Japan. (BL)

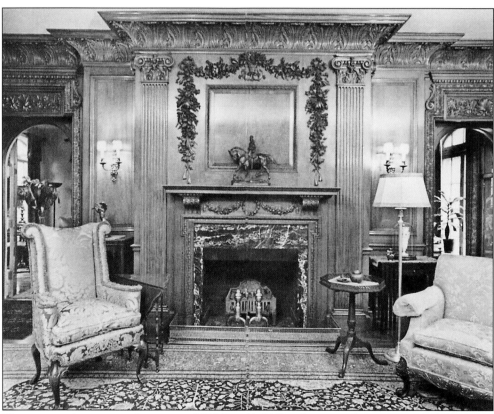

The exquisitely appointed interior of 283 Pondfield Road is one of its attractions. The living room, pictured above, is fully panelled in solid walnut with carved friezes, cornices, pilasters, and beautiful detailing that accentuates the marble fireplace. (BL)

Seven

Service, Clubs, and Leisure:
A Camaraderie of Interests

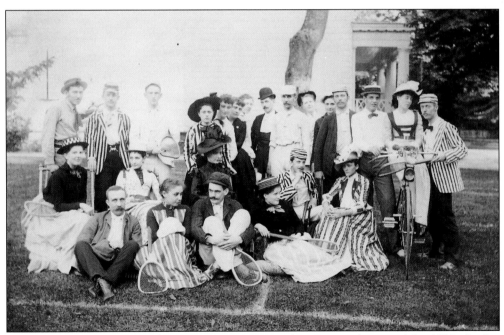

Bronxville's earliest organized sport was tennis, a popular new co-ed game of the 1880s. In this c. 1890 photo, the Bronxville Tennis Club is shown relaxing on the lawn of the Masterton-Dusenberry home. The colorful striped uniforms are a contrast to the "tennis whites" required by later clubs. Women claimed their voluminous skirts and large brim hats were no impediment to a good game. Hostess Amie Dusenberry is seated on the front row, second from left.

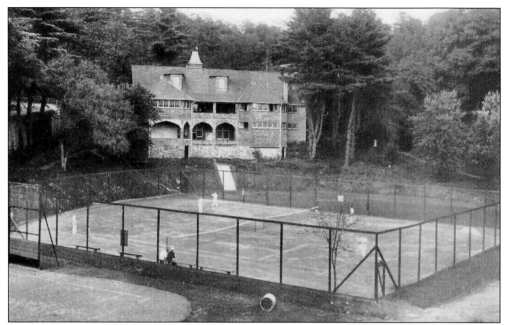

Tennis was only one of the activities available at the 1890s Casino, or Lawrence Park club house, seen here c. 1900. The popular Casino had an assembly room, dining room, kitchen, and locker room. In 1905, the Bronxville Athletic Association built six more courts on the site of the Garden Avenue parking lot.

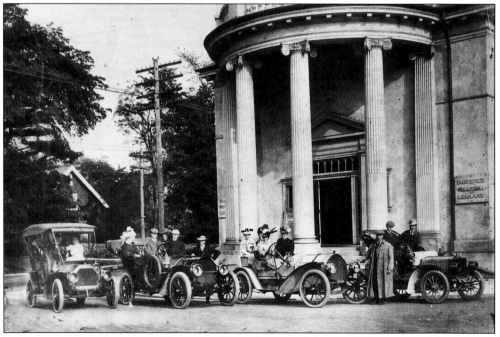

It was appropriate that a town that manufactured automobiles would have one of the nation's earliest auto clubs. Included in the club's 1909 official photo at old village hall are the wife and sister of local car designer Ward Leonard. The cars include a Mitchell, a Packard, and two Pierce Arrows.

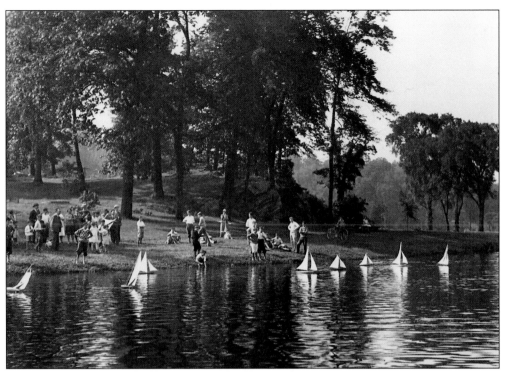

Bronxville Lake, formed by the Bronx River, was a popular site for model sailboat races in the 1920s. Entries were made in shop class at the school. In the early years, villagers swam in the lake until it became too crowded and swimming was prohibited.

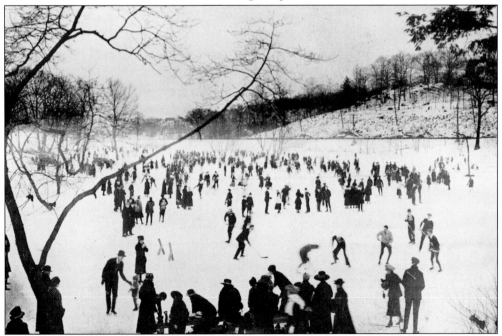

A favorite winter gathering place for children and adults in the early part of the century was the Bronxville Lake. Here residents enjoyed both skating and ice hockey.

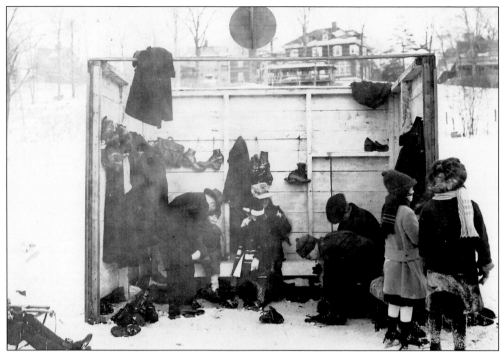

Two little girls wait to skate with their family in 1918. The small skate house offered a place to change and hang shoes before enjoying an afternoon on the ice.

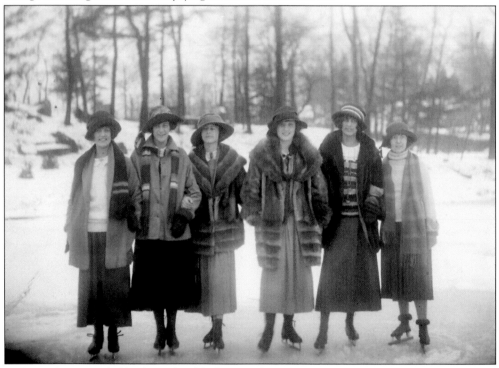

In December 1922, half a dozen local belles posed on the ice in their furs and hats. Jane Gray, the future Mrs. Elliott Bates, is fourth from the left. (EB)

Clubs with a variety of activities became very popular in the Bronxville area around the turn of the century. Pictured here, c. 1915, are members of the Lawrence Park Country Club, whose nine-hole golf course was located south of Palmer Road and west of Kimball Avenue. The fashionable sport was popular with women as well as men.

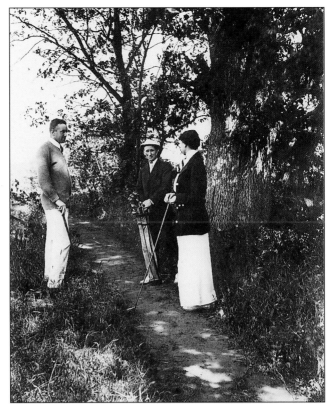

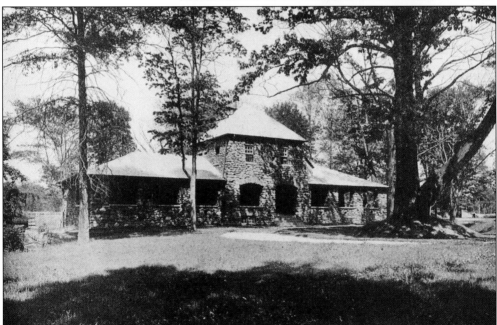

This stone club house on Palmer Road in Lawrence Park West was built in 1910 and served first as the Lawrence Park Country Club, next as the first Bronxville Women's Club (1925–27), and then as the Lawrence Park West Country Day School during the 1930s.

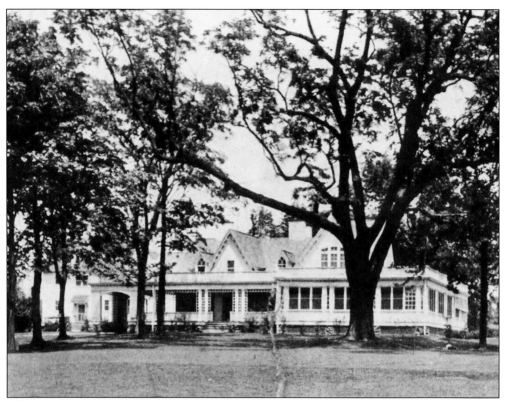

The Siwanoy Country Club, founded in 1901 as a men's golf club, was originally located in Mount Vernon. In 1913 the club moved to its present location, the Manor House was remodeled as a clubhouse (above), and an eighteen-hole golf course was constructed. The remodeled club also had eight tennis courts, but they gave way to a parking lot when cars became more important than tennis. In 1929, the present clubhouse was built. (SCC)

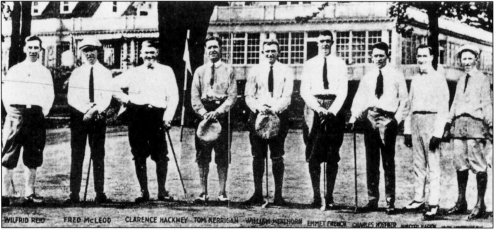

WILFRID REID FRED McLEOD CLARENCE HACKNEY TOM KERRIGAN WILLIAM MEHLHORN EMMET FRENCH CHARLES HOFFNER WALTER HAGEN

Siwanoy put itself on the golf-circuit map early in its history. In 1916 the first PGA Tournament was played at the club, and in 1921 these golfers traveled to Scotland to play in the British Open Championship at St. Andrews. In 1908 club members founded one of the most unusual golfing organizations in the country, the "Siwanoy Snowbirds," a competition for winter golfers who play no matter the weather. (SCC)

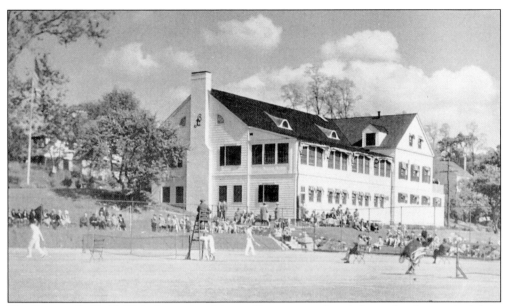

The Bronxville Field Club, located in Mount Vernon, was founded as a family tennis club in 1925. The club, pictured c. 1930, has been host to ranked tennis players and celebrities and served as an important social center for Bronxville residents.

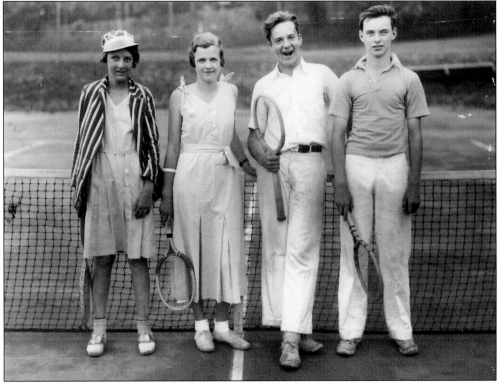

This youthful 1930s winning tennis team reflects the emphasis the club has placed on instructing young people in sports activities. Over the years the facilities have expanded to include a pool, bowling alley, and squash and paddle courts. (BFC)

Amateur theater has been a part of Bronxville's leisure activity since the nineteenth century. Shown here is a Reformed Church production in 1899. Among these performers were four that were well-known: (left, first row) Adele Bates Charlton and Amie Dusenberry; (left, second row) Mary Young Purdy and Marie Ferris.

The Bronxville Men's Chorus (c. 1915) is an early example of the area's long tradition of vocal music. The group was organized in 1912 and performed until World War I.

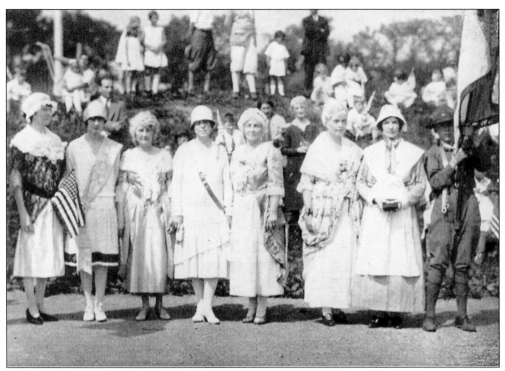

Service has been the cornerstone of much of Bronxville's club life. Members of the Anne Hutchinson Chapter of the Daughters of the American Revolution, founded in 1919, pose on July 4, 1928, in historical costumes.

Westchester
Connecticut

The New York Times

Sunday, October 20, 1929

Rotogravure
Picture Section

14

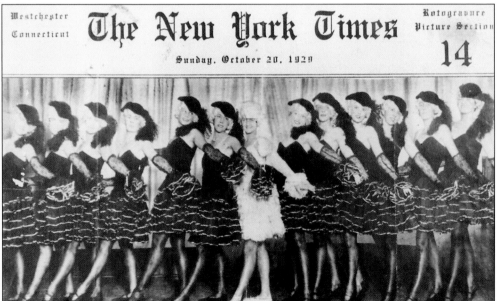

The League for Service performed their "Levities" on the eve of the disastrous stock market crash of 1929. That year, the annual community benefit had increased importance because of the severe economic depression that followed. Another important local service group, the Junior League, was established in 1948.

Boy Scouts exhibit a bridge built to span the Bronx River at the 1925 Father-Son dinner at the Hotel Gramatan. The Bronxville troop was organized in 1916, only six years after the founding of the national organization. The group was immediately popular with village boys, in part because of their dedicated leader, Rev. Otis T. Barnes.

Bronxville's Boy Scouts traveled to Washington, D.C., in 1932 and met with President Herbert Hoover on the White House lawn. Most were sons of Republican families.

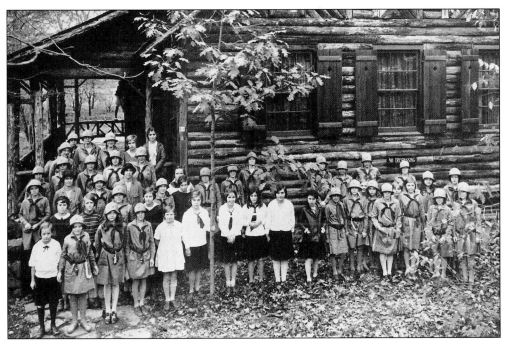

In 1929 several local Girl Scout troops posed in front of their new meeting place, the Betty Parker cabin. Bronxville's Girl Scouts were organized in 1917, one year after the Boy Scouts.

Bronxville's "poster girls" illustrate the three levels of scouting from Brownie to Senior Scout. For most young girls in the area, scouting has been their first club membership. (PP)

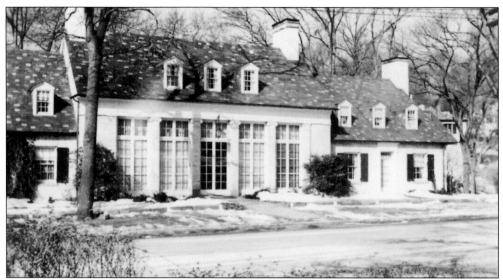

The Bronxville Women's Club, founded in 1925, has served as an intellectual, social, and service center for hundreds of local women. The club's literary and historical magazine, *The Villager*, published for over seventy years, was proclaimed by author John Galsworthy to be an "extraordinary little magazine." The 1928 clubhouse on Midland Avenue was designed and built by architect Penrose Stout on land donated by club founder Anna Lawrence Bisland.

Bronxville has long been home to a large group of international residents. Organizations such as the International Women's Group, founded in the 1970s, have provided forums for cultural exchange. Above, three local residents demonstrate the preparation of Japanese cuisine. (GN)

Eight

Pageants, Patriotism, and Ceremonies:
A Century of Celebration

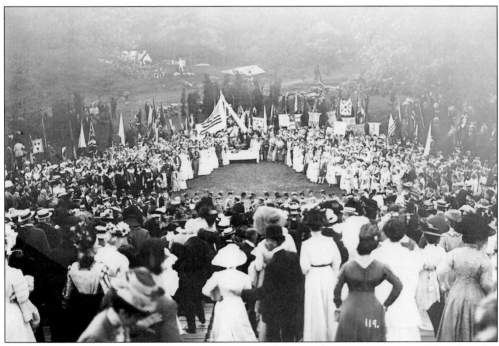

A dramatic moment in the history of Bronxville was the 1909 pageant. This four-day extravaganza combined the best of Bronxville's traditions: a grand-scale event, talented residents, and service for a charitable cause. Thousands of spectators gathered on the wooded hillside north of Avon Road to watch over six hundred villagers reenact scenes of Westchester history. Proceeds from the drama, costume ball, and formal bridge party were given to the newly established Lawrence Hospital.

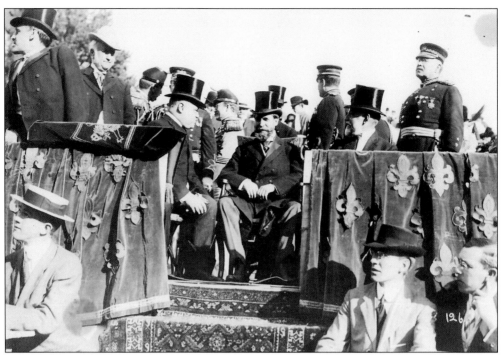

The 1909 pageant brought dignitaries and patrons from throughout the state. In the center is Governor Charles Evans Hughes, and in the upper left (in light hat) is William Lawrence, the driving force behind the event. Note the press corps on either side of the oriental carpet.

This scene from the 1909 pageant depicts the first recorded purchase of Westchester land from Native Americans by Jonas Bronck in 1639. Photos from this scene were the inspiration for the official Bronxville emblem portraying a silhouetted Bronck with wagon that has been used since the 1920s and has been incorporated into the 1998 centennial logo.

Bronxville's first Christmas dramatization, "The Christmas Mystery, 1914" was performed on the twelfth day of Christmas in the old Christ Church parish house. Fifty costumed villagers presented a three-part play set in Bronxville, World War I Belgium, and Bethlehem.

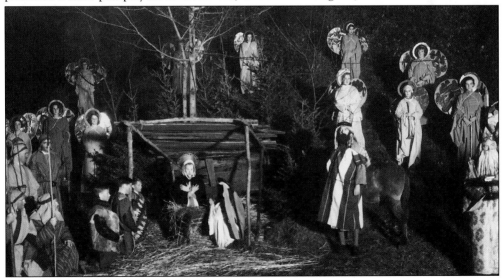

On December 24, 1915, the first traditional Christmas pageant was performed on a hillside below the Hotel Gramatan on Pondfield Road. Local citizens in elaborate costumes portrayed the Nativity, a drama that has since been reenacted annually. During the 1940s, the pageant was moved to the lawn of the Reformed Church.

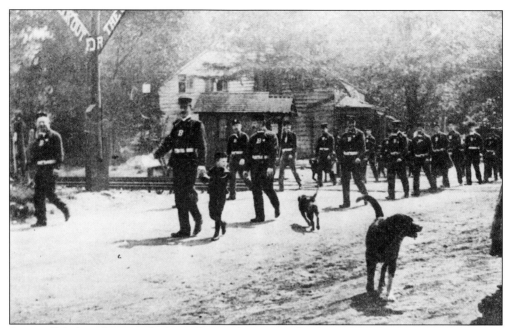

Bronxville's first photographed parade was this group of volunteer firemen from the local hose company. The group is marching in formation across the tracks on Pondfield Road, c. 1895, in front of Underhill's train depot.

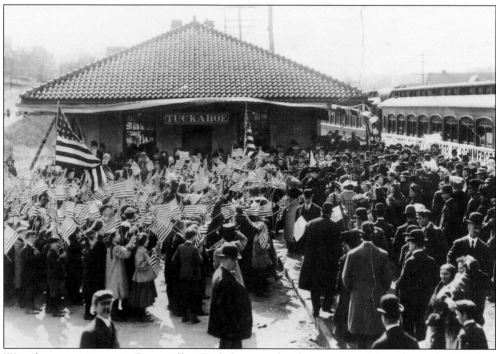

Westchester citizens in Bronxville, Tuckahoe, and other communities along the Harlem Railroad gathered in 1910 at local depots amidst excitement and pageantry to hear speeches by government and railroad officials hailing the arrival of the first electric-powered train. (EHS)

In 1898 while Bronxville was in the midst of incorporating as a village, young Bertrand G. Burtnett posed in his Spanish-American War naval uniform. This Masterton grandson later became a state assemblyman, newspaper editor, real estate salesman, school board chairman, and village historian. He lived to witness two world wars and the Korean conflict.

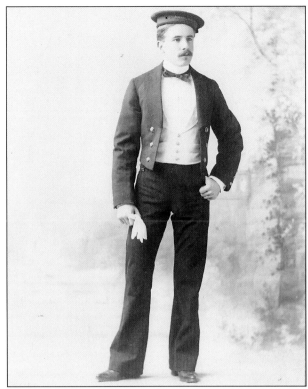

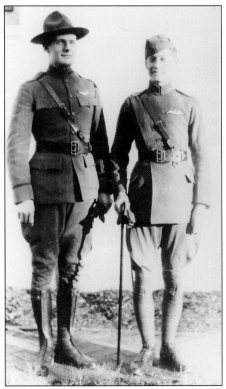

With the optimism of youth, Irving and Leonard Morange rushed to enlist in World War I. Leonard, the younger brother, left Yale to join the Royal British Flying Corps in 1917. He was killed in a flight accident. To honor him as the first Bronxville man lost in the war, the American Legion Post and a Bronxville park bear his name. Brother Irving succumbed to war-related injuries in 1926. In all, 233 men and 4 women from Bronxville were in war service. Their names are commemorated in memorials throughout the village.

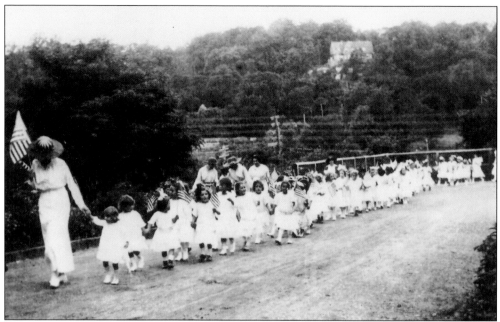

Patriotically waving their flags, these children marched from Tuckahoe to Avon Road in celebration of Independence Day in 1916. Before World War I, July Fourth was the primary day for patriotic celebration. (EHS)

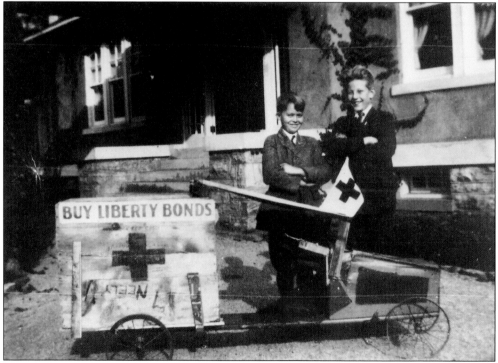

These young boys in front of the Gray home at 2 Governors Road have contributed to the war by making a go-cart to advertise the sale of Liberty Bonds. In all, Bronxville raised over $3 million, selling double its assigned bond quota. (EB)

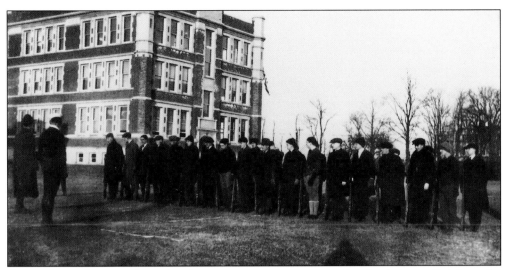

Concordia students performed military maneuvers in preparation for being called into the armed services. Legislation passed by the State of New York in 1918 required all able-bodied boys sixteen and older to participate in military drills. Bronxville boys in local high schools also drilled twice a week. Bronxville men organized a Home Defense Guard and wore khaki uniforms and carried weapons for their drills. During World War II, Concordia's enrollment dropped as male students volunteered and were drafted into service. (CC)

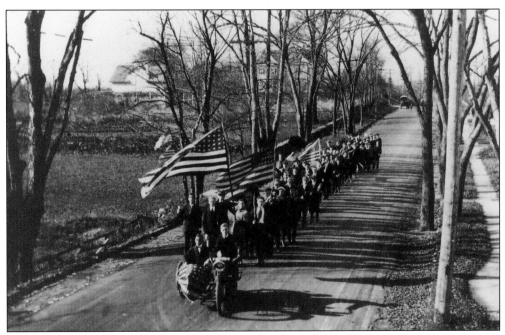

Concordia students organized their own "Peace Day" parade on Armistice Day, November 11, 1918. Though the war had ended, military drills continued through the spring of 1919. The area around the campus at White Plains Road and Tanglewylde remained undeveloped, which was an asset according to one student who enjoyed walking in wooded areas and open fields with friends. (CC)

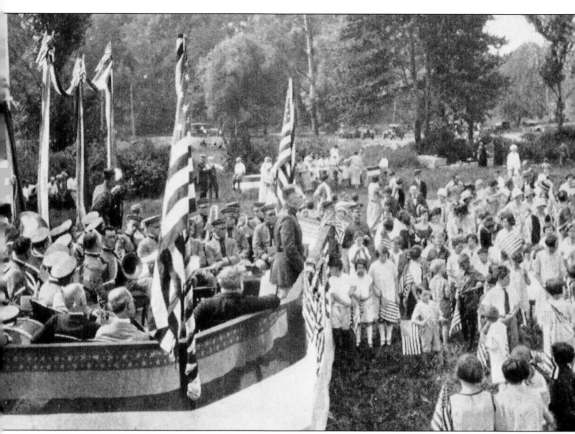

After World War I, villagers jointly celebrated their Independence and Defense Day parades on July Fourth. According to one account: "All able-bodied citizens between the ages of 18 and 45

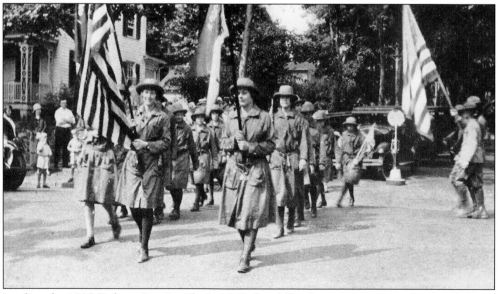

Leading the 1925 Defense Day Parade, local Girl and Boy Scouts serve as a color guard. Since their founding, the Bronxville scouts have been major participants in parades and ceremonies.

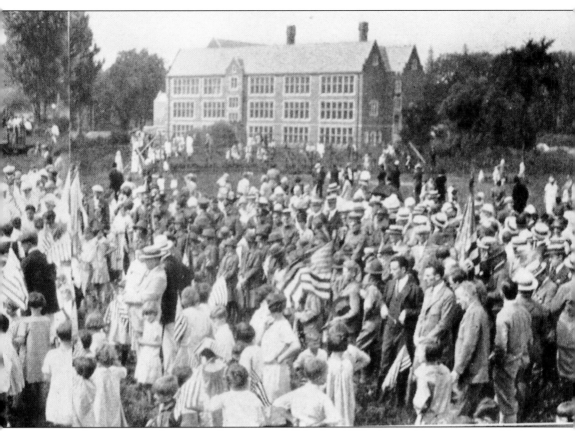

were urged as a matter of patriotic duty to march." In this 1925 photo, citizens are assembled around a festooned bandstand at the school field, listening to patriotic speakers and music.

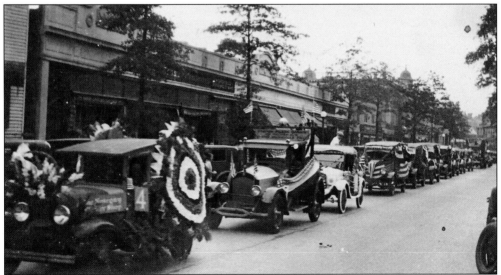

In 1926, patriotically draped autos parade down Pondfield Road. A car from Nosegay Florist leads, its hood decorated with flowers. The long building in the background replaced the old school.

Between the wars, when Americans were very demonstrative about their patriotism, Brantwood Hall crowned a May Queen by draping her in the American flag. Bronxville's women were as fervent in their patriotism as the town's men. On the eve of the U.S.'s entry into World War I, the local American Red Cross was organized, and through that organization women contributed significantly to both world wars.

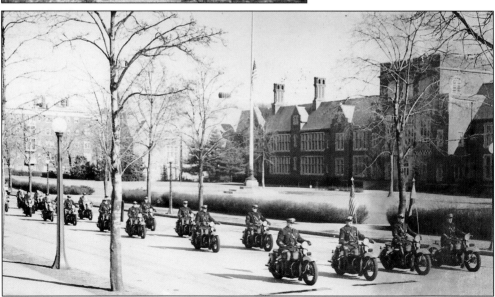

Honoring one of their own who has died, "Bronxville's finest" pass the school in perfect formation in the 1930s. In 1936 the city fathers decided to put patrolmen in cars, but the police objected strongly to giving up their motorcycles and the plan was abandoned.

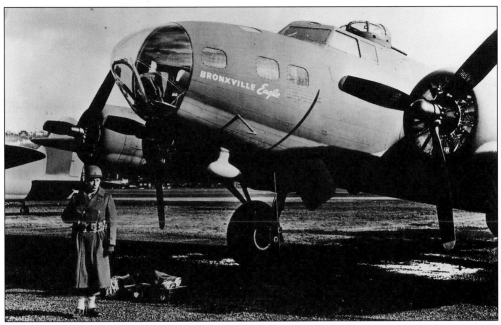

With the outbreak of World War II, Bronxville's citizenry rallied in support of the war both at home and abroad. A squadron of B-17 bombers, with names such as "Bronxville Eagle," "Bronxville Avenger," "Bronxville Liberator," "Bronxville Odyssey," "Trust Bronxville," "Spirit of Bronxville," "Pondfield Prowler," and "Chief Gramatan," assured any observer that New York's mile-square village was strongly represented on the side of the Allies.

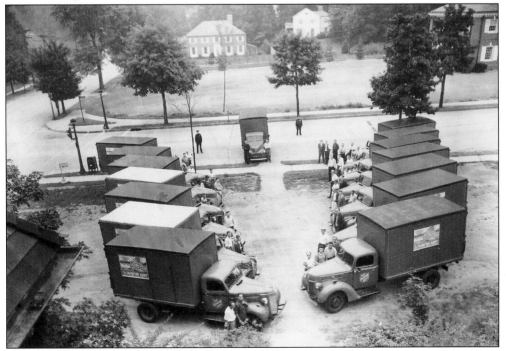

Salvation Army trucks assembled on the lawn of the new village hall, c. 1943, to collect scrap metal. A World War I cannon from the Leonard Morange Park was the largest donation.

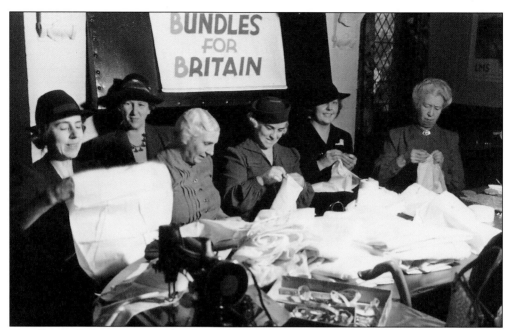

"Bundles for Britain" was a catchy slogan for part of the women's war effort. Women sewed and rolled bandages. Oakledge, the Purdy mansion off Pondfield Road, was the center for Red Cross work and became known as the "Red Cross House" thereafter.

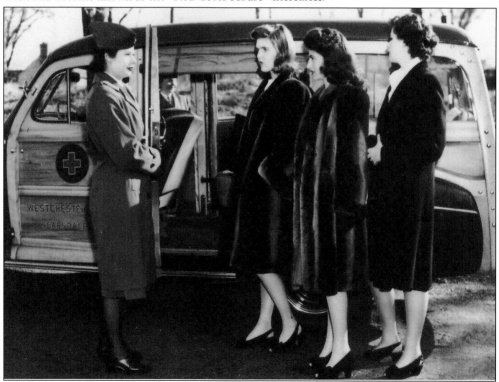

Dressed much differently from their counterparts of later decades, Sarah Lawrence students pose in fur coats and sling-back pumps before heading off to do war volunteer work. (SLC)

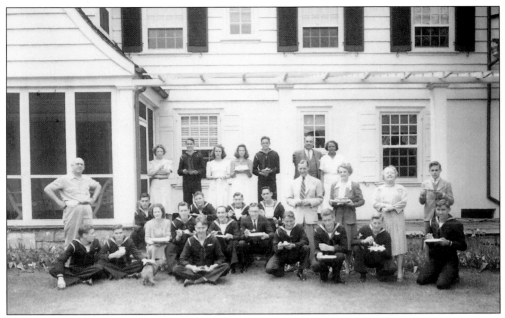

Nothing contributed more to the servicemen's morale than a meal and friendship in a private home. A number of villagers repeatedly opened their homes during the war to offer a little "R and R" to groups of servicemen.

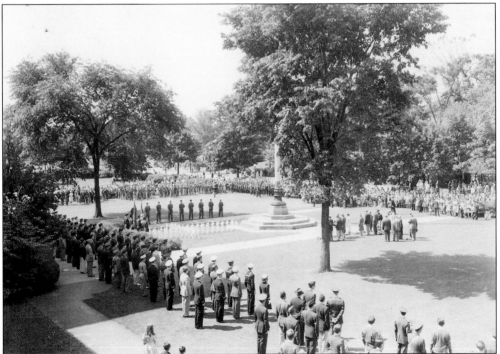

This 1946 Memorial Day ceremony is typical of those that have been observed for over seventy-five years. White crosses remind villagers of the servicemen and women who have died during the previous year. The Leonard Morange Post has organized the Memorial Day ceremony and parade since 1920 and 1921 respectively.

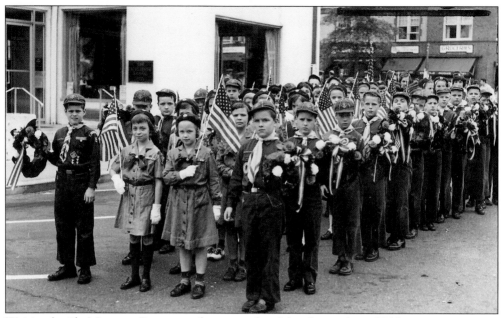

Waiting beside Morange Square on the west side of the depot, these 1960s scouts prepare to join others in the Memorial Day march to the local cemetery to place wreaths and flags on veterans' graves. The Memorial Day parade and festivities have always included residents from the broader Bronxville community as well as those from the village.

Bronxville historically has encouraged the participation of family members of all ages in its celebrations and ceremonies. For decades, Bronxville's youngest residents have looked forward to decorating their bikes, trikes, strollers, or big wheels to "bring up the rear" of the Memorial Day parade. In continuing this tradition, the 1998 centennial parade will be remembered as a spectacular event that celebrated the village's past and saluted her future—the beginning of another Bronxville century.